Queen Elizabeth II

PORTRAITS BY CECIL BEATON

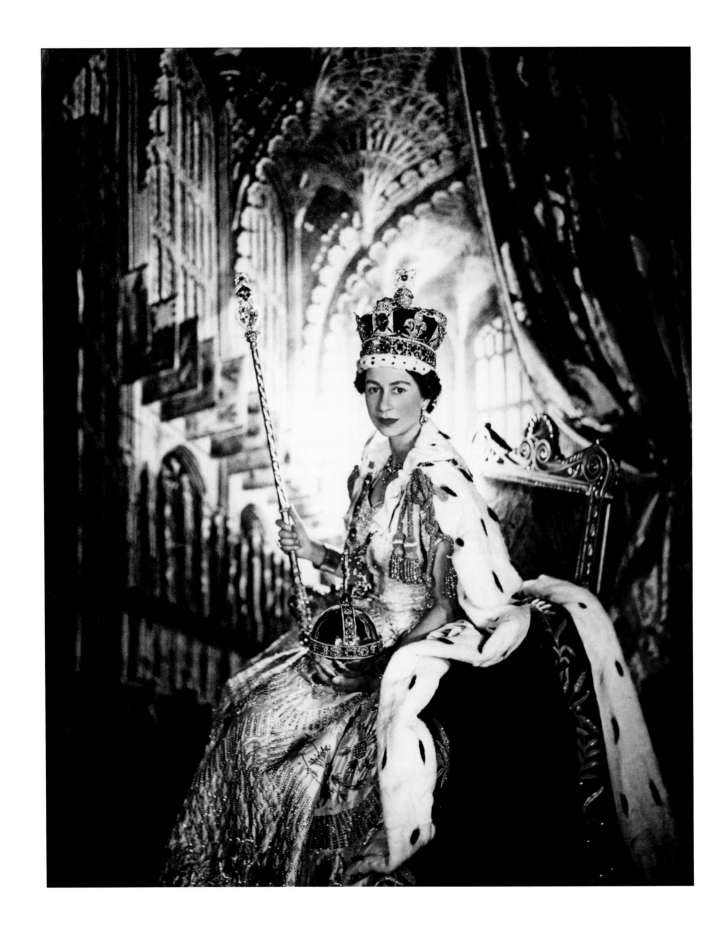

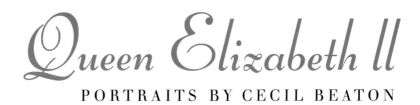

Queen Elizabeth II
PORTRAITS BY CECIL BEATON

Susanna Brown

V&A PUBLISHING

First published by V&A Publishing, 2011
Victoria and Albert Museum
South Kensington
London SW7 2RL
www.vandabooks.com

Distributed in North America
by Harry N. Abrams, Inc., New York

Hardback edition
ISBN 978 1 85177 654 2

Library of Congress Control Number 2011923015

10 9 8 7 6 5 4 3 2 1
2015 2014 2013 2012 2011

A catalogue record for this book is available
from the British Library.

Designer: Maggi Smith
Copy-editor: Linda Schofield
Index: Christine Shuttleworth

Front cover: Queen Elizabeth II and Prince Andrew,
March 1960 (pl. 48)

Back cover; page 2: Queen Elizabeth II, 2 June 1953 (pl. 16)

Page 11: Queen Elizabeth II, September 1968.
Gelatin silver print, 25.2 × 30.2 cm V&A: PH.1922–1987

Page 62: Queen Elizabeth II, September 1968.
Gelatin silver print, 30.4 × 25.7 cm V&A: E.1371–2010

Printed in Singapore

V&A Publishing
Supporting the world's leading
museum of art and design,
the Victoria and Albert
Museum, London

Contents

Foreword *Sir Roy Strong* 6

Preface 9

THE QUEEN AND CECIL BEATON 10

Afterword *Mario Testino* 58

PLATES 62

Notes 124

Select Bibliography 126

Acknowledgements 127

Picture Credits 127

Index 128

Foreword

Sir Roy Strong

THE ARCHIVE of Sir Cecil Beaton's royal portraits entered the collections of the Victoria and Albert Museum, via his devoted secretary Eileen Hose, as a tribute to my friendship with him from 1968 to 1980. Logically they should have gone to the National Portrait Gallery where, in 1968, I staged the landmark exhibition *Beaton Portraits 1928–68*. At the time, the exhibition caused a sensation and placed both the gallery and myself firmly onto the cultural map of 1960s 'Swinging London'. It was for that occasion that Cecil produced his last portrait of the Queen wearing an Admiral's Boat Cloak, an image endowed with an austere grandeur.

Looking back, it is true to say that there are those who stick firmly in the mind and those who vanish. Cecil remains not only a cherished memory but also a point of reference, for he possessed an extraordinary eye and unfaltering taste. The sundial from his little lavender garden at Reddish House, Broadchalke, where I used to stay with him all those years ago, now forms the focal point of a garden at The Laskett, my home in Herefordshire, laid out in honour of the Queen's Silver Jubilee in 1977. Christopher Gibbs bid for it for me in the sale after Cecil's death. The garden contains white 'Iceberg' roses, which he loved, recalling his injunction to me 'Remember, Roy, white flowers are the only chic ones'.

Beaton was an ambitious, complex, vain, observant and deeply patriotic man. More to the point, he had an ability that was to render him irreplaceable to members of the House of Windsor. No other photographer could wave a wand over even the most unpromising and unprepossessing of them with such magic, so that even the plainest and dullest members of the family were endowed with a certain aura and mysterious glamour. I recall strolling around the initial display of these royal images at the V&A in 1986 with the eminent theatre photographer, Zoe Dominic, who marvelled at Cecil's technical virtuosity. How he could make the camera smooth away the warts and all and yet also make every diamond sparkle.

Shortly after I resigned the directorship of the V&A, I reproduced a selection of the images from the Royal Archive in a book called *Beaton: The Royal Portraits* (1988). As my editor, the then young Michael Hall, said to me years later: 'That was about the last occasion that such a book could be written.' There was a truth in that observation. In 1988, when I put it together, the royal family remained largely untouchable. The marriage of the Prince of Wales to Lady Diana Spencer had lifted them to the summit. Thanks to Cecil's biographer, Hugo Vickers, I was given full transcripts of all his accounts of royal sittings. But not quite, for in the end Cecil applied his vicious pen even to the Queen and those words I was never allowed to see.

Still there was enough vitriol on the page from time to time. But all the old loyalty remained in place in 1988 and so, by the skilled use of ellipses and by cutting out chunks, virtually all of his royal sitters emerged at my hands unscathed. However, nothing ever escaped Cecil's eagle eye and he rarely minced his words. Of the Duke of Windsor in 1937: 'He has common hands – like a little mechanic – weather beaten and rather scaly and one thumb-nail is disfigured.' George VI was dismissed as 'without any mystery or magic whatsoever. One forgets after a few minutes that he is in the room'. Even his long friendship with Queen Elizabeth the Queen Mother flagged

when he commented in print upon her far from pearly teeth.

The 1968 Beaton exhibition also came at a particular moment when things were changing in the photographic world. Massive retouching was going out and we were entering the era of the 'in your face' photographic portraiture of the David Bailey kind. I recall the moment at the 1968 exhibition that Cecil licked his finger and rubbed off the retouching on a Coronation photograph of the Queen Mother saying 'Now it can be done.'

Although I hadn't taken it in at the time, Cecil was to an extent in eclipse. He once wrote a list of those whom he most envied and it began with the Queen, which explains both his soaring ambition and his reaction to the marriage of his rival, the photographer Anthony Armstrong-Jones, into the royal family. A friend of mine, the designer Anthony Powell, was staying in the house when someone rang with the news. The look on Cecil's face had to be seen to be believed. Much later, I did my best for him. On the one occasion that I was taken out to lunch by a key figure who handled Honours, I said that Beaton should be knighted. The person concerned looked surprised and asked why. I said that Beaton's work had contributed to saving the monarchy after the abdication by creating a new image for it. The knighthood followed.

In spite of all the cattiness and envy, Cecil was a devoted monarchist. In 1974 came the terrible stroke. When I could, I visited him and one such occasion captured exactly his belief in the Crown. The year was 1977 and the Queen's Silver Jubilee. I recall sitting at lunch at Reddish with Cecil of course at the head of the table longing for all the London gossip. I described at length what I had seen that day when, in the evening, I had walked home via The Mall and joined the crowds clamouring for the Queen to appear. It was unforgettable, an occasion of such loyalty that the vast crowd burst into 'Land of Hope and Glory'. As I painted to him this word picture, the tears streamed down his face. It was to be my last memory of Cecil. Three years later, I travelled down to the funeral and later acted as an usher at his memorial service in London. I revere his memory.

Graham Hughes, Sir Roy Strong admires a Beaton photograph at the exhibition *Beaton Portraits 1928–68*, November 1968

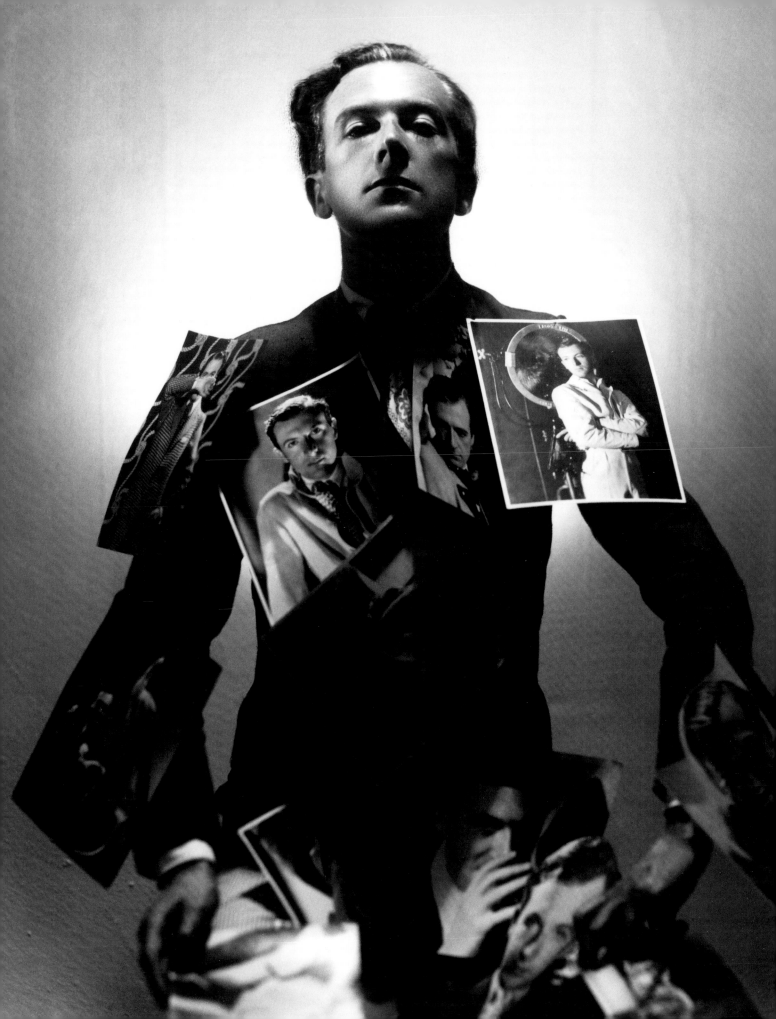

Preface

THE PHOTOGRAPHS of the British royal family by Sir Cecil Beaton (1904–80) are among the most widely-published portraits of the twentieth century and were intrinsic to the shaping of the monarchy's public image from the 1930s to the 1960s. In his long career as a royal photographer, Beaton was granted sittings with almost 30 members of the House of Windsor. He was one of the great diarists of the twentieth century and his personal diaries are crucial to an investigation of his career. Preserved today at St John's College Library, Cambridge, are 145 volumes, filled with fascinating accounts of many sittings, including his first meeting with Queen Elizabeth (1900–2002; later the Queen Mother) in July 1939:

> *The telephone rang. 'This is the lady-in-waiting speaking. The Queen wants to know if you will photograph her tomorrow afternoon.'*
>
> *At first, I thought it might be a practical joke … but it was no joke. My pleasure and excitement were overwhelming. In choosing me to take her photographs, the Queen made a daring innovation. It is inconceivable that her predecessor would have summoned me – my work was still considered revolutionary and unconventional.*[1]

This book explores Beaton's long relationship with the royal family, and Queen Elizabeth II (b.1926) in particular, whom he first photographed as a teenage princess in 1942. His portraits are enlivened by extracts from his diaries, and the accounts of those who sat for him and worked with him. It is a celebration of the career of a 'romantic royalist',[2] who distilled myriad sources of inspiration to produce images with the power to shape the public's perception of a princess, monarch and mother.

Beaton and the V&A

Cecil Beaton's relationship with the Victoria and Albert Museum (V&A) began in 1970 when the Museum's Director, John Pope-Hennessy, invited him to form a collection of twentieth-century British fashion on behalf of the Museum. Over 400 outfits and accessories were donated and shown in the 1971 exhibition *Fashion: An Anthology by Cecil Beaton*. The highlights included an evening dress designed by Hardy Amies and worn by Queen Elizabeth II at the State reception in Brühl in May 1965; a Chanel sequinned evening suit worn by the fashion editor Diana Vreeland; and a white crêpe evening dress by Givenchy worn by Audrey Hepburn. The list of 143 illustrious donors in the exhibition catalogue can be construed as a glimpse of Beaton's personal address book. Throughout his long and varied career in Europe and America, he formed friendships with royalty and aristocracy, and with some of the twentieth century's greatest designers, artists, actors and writers.

The royal portraits by Cecil Beaton form one of the largest bodies of work by a single photographer in the V&A collections. Bequeathed to the Museum in 1987 by Beaton's long-time secretary, Eileen Hose MBE, the archive consists of approximately 18,000 vintage prints, negatives and transparencies, as well as 45 volumes of the photographer's press cuttings. Also included in the V&A collections are some of Beaton's glittering fashion studies for *Vogue* magazine and photographic portraits of him taken throughout his life by his contemporaries.

Paul Tanqueray, Portrait of Cecil Beaton, 1937
V&A: PH.443-1982

The Queen and Cecil Beaton

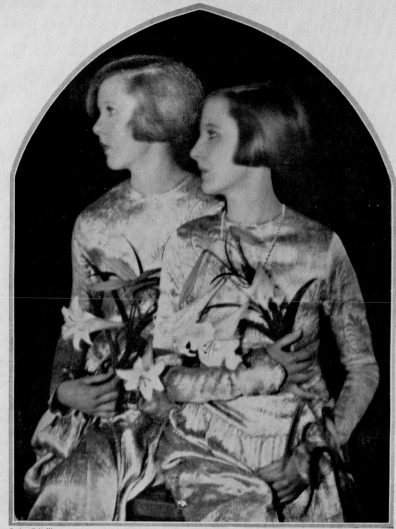

See pages 47 and 48.

HOST & HOSTESS

Carlos Crivelli.

Nancy and Baba
daughters of M^r & M^{rs} E. W. H. Beaton.

Society ~ Fiction ~ Art ~ Home ~ Plays
Travel ~ Children ~ Beauty ~ Modes ~ Menus

N.°139 Vol. XV. *One Shilling.* *January 1926.*

Fig. 1
Carlos Crivelli (a pseudonym used by Cecil Beaton)
Nancy and Baba Beaton on the cover of *Host & Hostess* (January 1926)

A Premier Portrait Photographer

'I have wonderful plans, and am going to do marvellous things in photography soon.'[1]

CECIL BEATON began to pursue photography at a very early age. As the proud 12-year-old owner of a No. 3A Folding Pocket Kodak camera, he whiled away many hours at his parents' Hampstead home, attempting to recreate the look of society portraits by well-known photographers Lallie Charles (1869–1919) and her sister Rita Martin (1875–1958), among others. The Kodak replaced Beaton's earlier Box Brownie and had the advantage of producing a film negative the size of a postcard, which could be retouched with a scalpel and was available in four, six or ten exposure lengths. He would continue using this simple Kodak camera for many years to come.

Without access to a daylight studio he often photographed outdoors, substituting his two patient younger sisters for stars of stage and screen. Endlessly inventive, the boy employed bed sheets as backdrops and accessorized his shots of Nancy and Barbara ('Baba') with his mother's ornaments, flowers from the garden and homemade props: 'A large bath-towel and two safety-pins were all that were needed,' he wrote, 'to make an excellent imitation of a wedding dress from Worth or Réville and Rossiter.'[2] He also imitated the chic 'At Home' portraits by Miss Compton Collier (active 1910s–1950s) and studies by Hugh Cecil (1892–1974) that appeared in weekly society publications, including *The Sketch* and *Tatler*.

Much of Beaton's early inspiration was drawn from the magazine *Vanity Fair*, a copy of which, he

later claimed, was always by his father's bedside.[3] In these early years, he was taught how to develop his own film by Alice Louise Collard (his sisters' nanny, affectionately known as Ninnie, and an amateur photographer). Occasionally assisted by his younger brother Reginald, he would spend long evenings bent over basins of photographic chemicals, printing by gaslight in his bedroom.

A student of Art History and Architecture at Cambridge University from 1922 to 1925, Beaton

Fig. 2
Baron Adolf de Meyer, Unpublished fashion study for *Vogue*, *c*.1919. V&A: PH.210–1985

spent little time attending lectures, focusing his energies instead on photography, theatrical clubs and forging new friendships. For the small sum of a half-crown per week, he rented a loft for use as a painting and photography studio.[4] With assistance from an electrician in the shop below, he set up a bright electric light to create back-lighting effects similar to those he admired in the sparkling, romantic fashion studies by Baron Adolf de Meyer (1868–1949; fig. 2), the first full-time photographer at American *Vogue*, who went on to work for *Vanity Fair* and *Harper's Bazaar*.[5]

Beaton carefully preserved many press cuttings from this period. The cuttings include his portrait photographs of other amateur dramatists and theatre reviews that reveal his active involvement as both designer and actor in the all-male Footlights Dramatic Club and Amateur Dramatic Club at Cambridge. Slender, with delicate features, he was convincing in female roles. Dressed as a woman for the Footlights' revue *All The Vogue* in 1925, Beaton sat for his portrait at the Bond Street studio of Dorothy Wilding (1893–1976) and was thrilled by the results (fig. 3). Neither Beaton nor Wilding could have known then that, despite their differing approaches to portraiture, they would both go on to enjoy long and successful careers as royal photographers.

Self-portraits of Beaton in costume were printed as a triptych in one newspaper, in December 1925, with the caption: 'Three Studies by Carlo Crivelli'.[6] This was a pseudonym occasionally used by Beaton and several portraits of the Beaton sisters appeared in the press in the mid-1920s credited to Crivelli (fig. 1). It is not clear why he chose the name of this fifteenth-century Italian painter. What is certain is that Beaton frequently visited the Fitzwilliam Museum during his years at Cambridge and drew heavily on its collection of paintings for inspiration. Examples of Crivelli's religious scenes survive in London's National Gallery and the Fitzwilliam. Perhaps he saw them there and felt an affinity with the painter, who made decorative use of flowers, fruits, and lavishly detailed carpets and textiles. Or, perhaps, it was merely the appeal of an exotic name. His student diaries reveal the extent to which Beaton sought to emulate the styles of well-known painters, including Rembrandt van Rijn, Thomas Gainsborough and Jean-Baptiste-Camille Corot. The influence of painting continued in later years; Beaton wrote of one memorable sitting with the poet Edith Sitwell: 'She posed wearing a flowered gown like Botticelli's Primavera; she sat on a sofa wearing a Longhi tricorne and looking like a Modigliani painting … and, wearing an eighteenth-century turban and looking like a Zoffany.'[7] In the late 1920s, Beaton's friendships with the three gifted Sitwell siblings – Edith, Osbert and Sacheverell – would enable him to enter a realm populated by wealthy and creative individuals, including Stephen Tennant, Rex Whistler and other 'Bright Young People'.

The 1924 summer holiday presented Beaton with a first, and unexpected, opportunity to photograph royalty, when his whole family made a car journey to Sandringham, Norfolk, to see the royal gardens. It was the day of the annual flower show and Her Majesty Queen Alexandra (1844–1925) attended. Beaton greatly admired Alexandra as 'a fantastic figure from an unbelievable past grandeur'[8] and attempted to photograph her from a distance – 'with silhouette as simplified as that of a Minoan sculpture' – as she walked among the crowds.[9] He was later disappointed to discover that the combination of his hand-held camera and cloudy weather had resulted in useless negatives. He purchased a tripod soon afterwards, to steady the camera during long exposures.

Beaton's apparent lack of technical knowledge was far outweighed by his creative flair. Equally essential to the photographer's ascendance were his great talent for social climbing and a voracious appetite for success. One scholar has suggested that Beaton's amateurism was a pretence, that 'Beaton guarded his own mystery by professing not to know how he managed the feat.'[10] By the mid-1920s, he undoubtedly possessed a professional grasp of lighting techniques and an artist's eye for composition. Among Beaton's early friends in the photographic world was Paul Tanqueray (1905–91), whom he first met in 1925. Tanqueray introduced him to the photographic printing company Messrs Jeffery & Boarder, which Beaton would use for many years subsequently, until the firm folded in 1955.

THE QUEEN AND CECIL BEATON 15

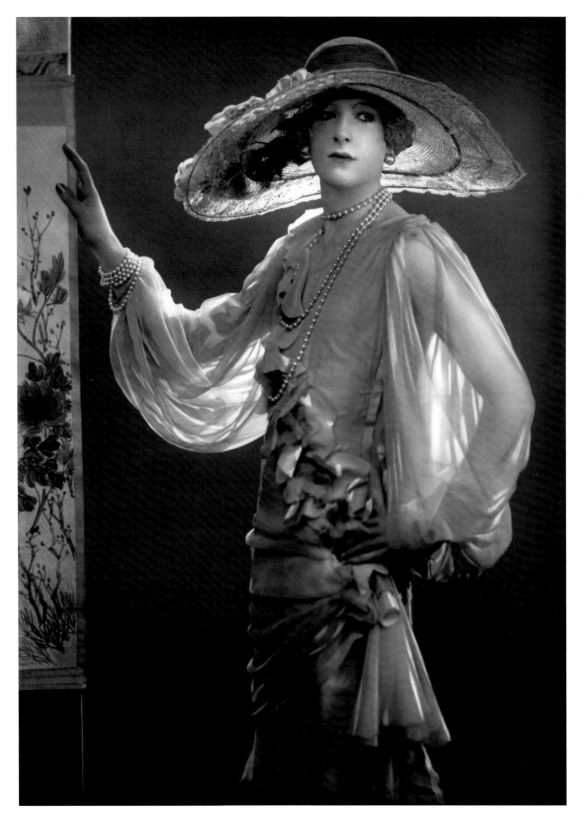

Fig. 3
Dorothy Wilding, Cecil Beaton in costume for the
Cambridge Footlights' revue *All The Vogue*, 1925

16

Fig. 4
Curtis Moffat, Portrait of Cecil Beaton, *c.*1930
V&A: E.1557–2007

Another inspiring acquaintance was Curtis Moffat (1887–1949; fig. 4), of whom Beaton later wrote:

Curtis Moffat, whose abstract photographs and huge marble-ized heads were extremely fashionable at this time, was friendly and encouraging, and I was extremely impressed by the flat lighting, or lack of lighting, and the compositions, or lack of composition, which he employed. In imitation of his work I hurried home to strip my sisters bare to the shoulders and bring my camera in so close to their faces as almost to touch their noses. I, too, bought a great variety of different-textured cardboards and coloured fancy papers on which to mount my Herculean enlargements; but my imitations never possessed the inimitable Curtis Moffat touch.[11]

Beaton's photographic career took off after leaving Cambridge without a degree in 1925. The following summer, his confidence was buoyed up by a visit to a clairvoyant, a Mrs Salisbury, who foretold an incredible future of realized ambitions. She ended her predictions by saying (noted in Beaton's diary at the time as being 'utterly unbelievable'), 'You'll have a lot to do with royalty.'[12]

In 1927, Beaton signed his first contract with *Vogue* to supply both photographs and hand-drawn illustrations to the magazine. By now, *Vogue* and *Vanity Fair* had replaced the velvety pictures by Baron de Meyer with precisionist studies by Edward Steichen (1879–1973), dubbed 'America's court portraitist'. Beaton's experimental early photographs for *Vogue* provided a counterpoint to Steichen's harder-edged approach: 'Steichen's pictures were taken with an uncompromising frankness of viewpoint, against a plain background, perhaps half-black, half-white, my sitters were more likely to be somewhat hazily discovered in a bower or grotto of silvery blossom or in some Hades of polka dots.'[13] Beaton greatly admired the *Vogue* chief photographers, Maurice Beck (1886–1960) and Helen Macgregor (active 1930s–1950s), and drew inspiration from their use of reflective surfaces and textured backdrops. His most accomplished *Vogue* images were both elegant

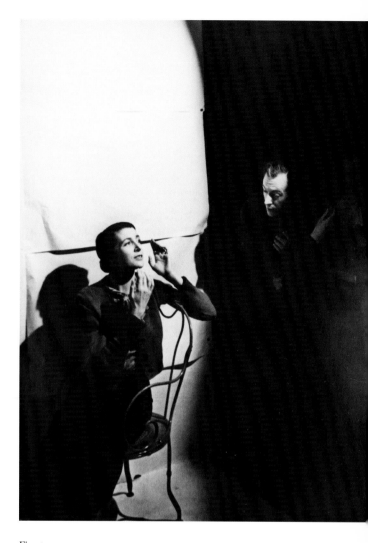

Fig. 5
Erich Salomon, Cecil Beaton at work in *Vogue* Studios, Paris, 1936. V&A: E.126–2003

and romantic. In 1944, the newly appointed *Vogue* Art Director, Alexander Liberman, wrote to Beaton of his remarkable contribution to the magazine: 'I am sure that you came at a time when a message of understatement, taste and naturalness was necessary to a hard and brazen world.'[14]

Soon after joining *Vogue*, Beaton's first solo exhibition opened, at the Cooling Galleries in London in November 1927, establishing him as one of the leading portrait photographers of his generation. The opening party was attended by

Fig. 6
W. & D. Downey, Portrait of King Edward VII
as Grand Master of the Freemasons, *c.*1905

Fig. 7
Cecil Beaton, Francis Rose poses as the fictional
Baroness von Bülop, *My Royal Past* (1939)

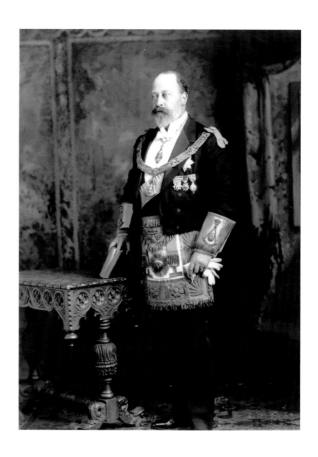

800 guests and newspaper reviews declared it
a fantastic success, marvelling at the illustrious
sitters, elaborate sets and innovative camera
angles. The *Sunday Herald* proclaimed:

> *Cecil Beaton, the wonder boy, artist, and*
> *photographer, is the talk of the town at the*
> *moment. Not to have seen his exhibition is*
> *to own yourself a nobody.*
>
> *The private view was a fascinating affair.*
> *Cocktails were provided, because critics are so*
> *absinthe-minded, and there was the enthralling*
> *spectacle of thrilling beauty trying to look*
> *exactly like its picture. I found the work of this*
> *clever and unconventional artist, who is not*
> *yet twenty, very refreshing after a view the day*
> *before of some chocolate-box family portraits*
> *by Laszlo, for so long the pet portrait-painter*
> *to Society with a big, big S.*[15]

Photographs and drawings of society beauties,
Hollywood stars and royalty were published in
Beaton's first book, *The Book of Beauty*, in 1930.
His fascination with high society and royalty
would lead, nine years later, to his humorous
book, *My Royal Past*, a volume of illustrated
memoirs by the fictional Baroness von Bülop,
the Lady-in-Waiting to the equally fictional Grand
Duchess of Hansburg. Published in 1939, the book
was written by Beaton himself, who convinced
his artistic friends, including Francis Rose, Tilly
Losch, Frederick Ashton, Antonio Gandarillas and

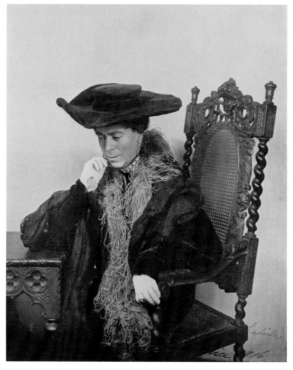

Fig. 8
Cecil Beaton, 'In the Manner of Edwardians',
Vogue (May 1935). V&A: PH.191–1977

Fig. 9
Cecil Beaton, Portrait of the Duke of Kent, c.1932
V&A: PH.641–1987

Fig. 10
Cecil Beaton, Portrait of the Duchess of Kent, 1938
V&A: PH.644–1987

Christian Bérard, to pose in elaborate costumes for photographs styled in imitation of the work of Victorian and Edwardian Court photographers. Several of the portraits were shot in the historic studio of the firm W. & D. Downey, at 61 Ebury Street, London. The Downey studio was in decline by the 1930s, but had, in earlier decades, received much royal patronage. Brothers William and Daniel founded the firm in the mid-1850s, and in 1866 William was invited to Balmoral to take the first of many Downey photographs of Queen Victoria (1819–1901). By the 1870s, the Downey brothers were established as leading Court photographers producing highly popular, collectable portraits. Some of the old studio backdrops and props still remained when Beaton used the Ebury Street studio, including a table that King Edward VII (1841–1910) had posed beside (figs 6 and 7) and a stone bench that features in numerous Downey portraits of celebrated actresses.

By 1938, Beaton was a sought-after portrait photographer on both sides of the Atlantic and had photographed many famous faces, including Tallulah Bankhead, Pablo Picasso, Katharine Hepburn, Marlene Dietrich, Salvador Dalí and Coco Chanel. Numerous members of the royal family had sat for him too, including Princess Louise, Duchess of Argyll, The Duke and Duchess of Kent (figs 9 and 10), The Duke and Duchess of Windsor and The Duchess of Gloucester. Yet his most significant royal sittings were still to come, beginning with Queen Elizabeth in 1939.

The Royal Family and the Portrait Tradition
The opportunity in 1939 to photograph Queen Elizabeth, Consort to King George VI (1895–1952), was the apotheosis of Cecil Beaton's career to date. The instant rapport that he struck up with the Queen resulted in Beaton remaining a favoured royal photographer for decades to come.

It is clear from Beaton's lengthy diary account that the first sitting with the Queen was a great success. Having been warned that he would not be permitted much time with her – 'not since the late King George's reign had any photographer been allowed to take pictures for more than

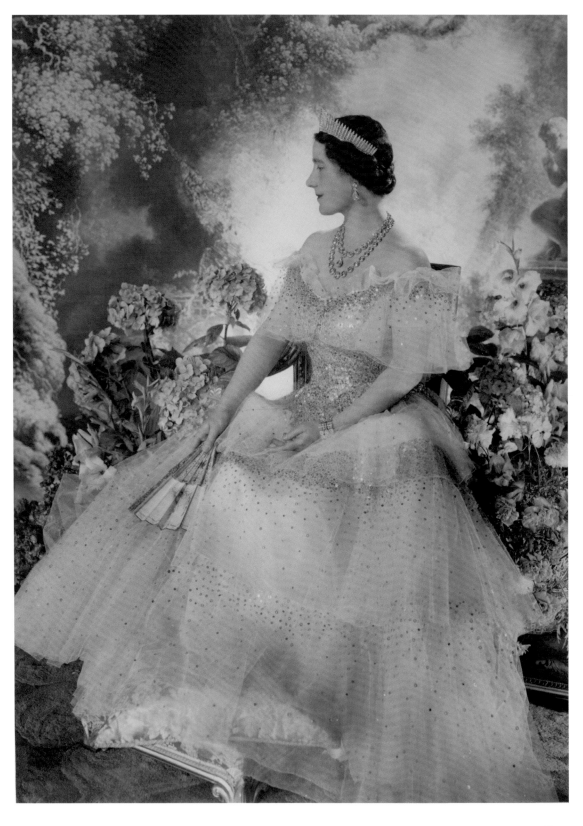

Fig. 11
Cecil Beaton, Portrait of Queen Elizabeth, 1939
V&A: PH.223-1987

Fig. 12
Cecil Beaton, Portrait of
Queen Elizabeth, 1939
V&A: E.1374–2010

twenty minutes' – the sitting lasted over three hours.[16] One of the 100 or so photographs he took that day was displayed in a frame on Beaton's desk in the 1940s, evidence of his admiration and affection for the Queen and the pride he took in his role as royal photographer.[17]

In 1923, Elizabeth Bowes-Lyon had married Albert, Duke of York, the second son of King George V (1865–1936) and Queen Mary (1867–1953). As the Duchess of York, she became accustomed to posing for royal photographers such as Bertram Park (1883–1972), Marcus Adams (1875–1959) and

Dorothy Wilding, all of whom depicted the Duchess as an elegant but essentially down to earth woman (fig. 13). In 1936, Britain was shaken by a constitutional crisis, when King Edward VIII (1894–1972), the Duke of York's brother, abdicated to marry the American divorcée Mrs Wallis Simpson. Next in line to the throne, Albert thus became King, taking the regnal name George VI. In his first photographs of the new Queen, Beaton transformed her from a demure mother into a glamorous fairy queen. In front of his lens, she became a romantic, ethereal figure, gliding

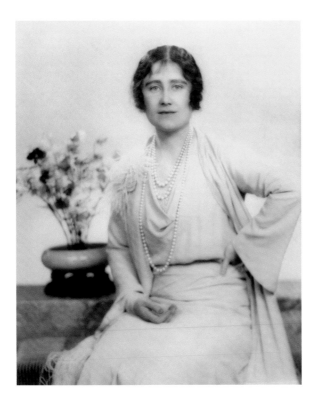

Fig. 13
Bertram Park, Portait of the Duchess of York, 1931

Fig. 14
Camille Silvy, Portrait of Princess Alice, July 1861

through the Palace gardens and gracefully posing in grand interiors, or against lavishly painted backdrops, surrounded by blooms of roses, lilies and hydrangeas (figs 11 and 12). The flowers that appear in so many of Beaton's portraits were often picked from his own garden and were an essential prop in his creation of idealized arcadian scenes.

Since Queen Victoria's reign, monarchs had exploited the power of photography to disseminate their images throughout the world. In March 1842, Prince Albert (1819–61), husband to Queen Victoria, became the first member of the British royal family to be photographed. In the 1860s, millions of royal cartes-de-visite – small mass-produced photographs mounted on card – were produced by photographers such as John J.E. Mayall (1813–1901) and W. & D. Downey, and avidly collected by the public. Photography has been credited with stabilizing the widowed Victoria's position of supremacy in the face of a growing republican movement.[18] Subsequent generations of royalty continued to use the medium as an essential public relations device. With the advent of half-tone printing in the 1880s, photographs gradually

began to replace engravings in newspapers and magazines, and the 1937 Coronation photographs of King George VI and Queen Elizabeth were widely published in the press.[19]

Beaton's first photographs of Queen Elizabeth consciously evoked the long tradition of painted portraiture, in particular the work of Thomas Gainsborough and Franz Xaver Winterhalter. Beaton's enduring fascination with Gainsborough began at Cambridge, where he visited the Fitzwilliam Museum to study the painter's sensitive portraits and poetic landscapes. His photographs of the Queen echo the soft luminosity of Gainsborough's portraits of Georgiana Duchess of Devonshire (1783) and Queen Charlotte (c.1781; fig. 15). In photographs from this sitting, the Queen poses with a closed fan, perhaps an overt reference to the latter portrait, while her delicate, feminine hand gestures closely imitate those of Gainsborough beauties Grace Dalrymple Elliott (c.1778; fig. 16) and Mary Robinson (1781). Entries in Beaton's diaries indicate that the Queen was an active participant in the staging of her portraits, often suggesting suitable garments and accessories.

Winterhalter's portrait of Elisabeth of Bavaria, Empress of Austria (1865; fig. 17), wearing a sparkling white off-the-shoulder gown, clearly influenced Beaton's first pictures of the Queen. In a later sitting, Beaton even commissioned a painted backdrop from Martin Battersby in order to create his own version of Winterhalter's portrait of Empress Eugénie (c.1852). In aligning his photographs with Winterhalter's poetic and ravishing royal portraits, Beaton reinforced the stability and historical relevance of the British monarchy post-abdication, portraying Queen Elizabeth as the current heroine in a long succession of beautiful queens and princesses.[20]

Beaton also replicated the techniques of Camille Silvy (1834–1910), one of the most accomplished royal photographers of the previous century. During the 1860s, Silvy photographed many members of the royal family and most of the British aristocracy (fig. 14). At the height of his success, he employed 40 staff at his London studio. Although Beaton never owned studio premises, he made use of accessories much like those of Silvy's studio. These included large backdrops of architectural views and landscapes, and props such as mirrors and low footstools to create a pleasing serpentine curve to the body.

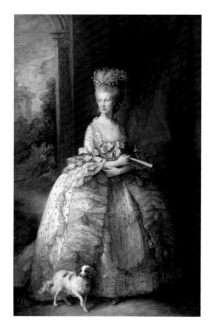

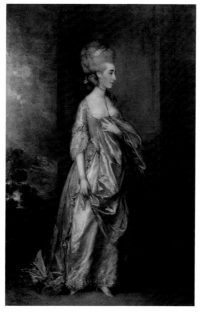

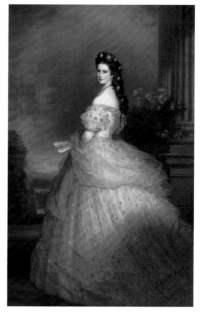

Fig. 15
Thomas Gainsborough,
Queen Charlotte, c.1781

Fig. 16
Thomas Gainsborough,
Grace Dalrymple Elliott, c.1778

Fig. 17
Franz Xaver Winterhalter, *Elisabeth of Bavaria, Empress of Austria*, 1865

Fig. 18
Cecil Beaton, Portrait of Queen Elizabeth, 1939
V&A: PH.947–1987

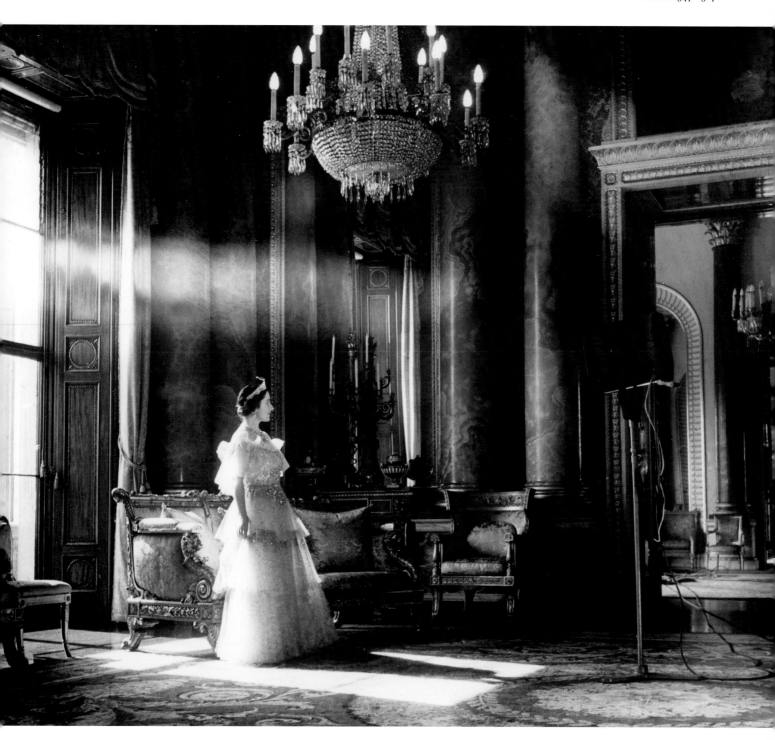

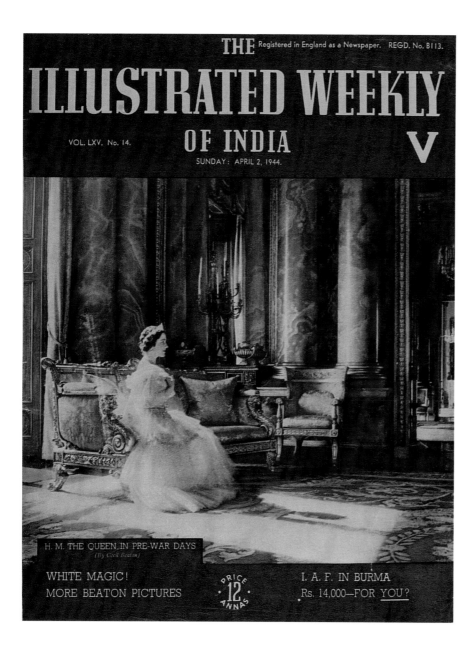

Fig. 19
Queen Elizabeth on the cover
of *The Illustrated Weekly of
India* (2 April 1944)

The photographic backdrops Beaton favoured were based on well-known masterpieces and were mainly produced by a firm in Ealing, west London. They included a reversed version of Jean-Honoré Fragonard's rococo confection, *The Swing* (1767), with the figure of the young woman removed; Roman ruins from an engraving by Francis Vivares after Giovanni Paolo Panini; and the *trompe-l'oeil* arcade in the Palazzo Spada in Rome by Francesco Borromini.[21]

To obtain such intimate but impressive portraits required much advance planning, numerous assistants and lighting technicians. For most royal sittings, the locations and outfits were agreed upon in advance. An uncropped image of the Queen in the Blue Drawing Room at Buckingham Palace reveals one of the tall studio lights that Beaton employed (fig. 18). While sunlight streams in through the window behind the Queen and onto the

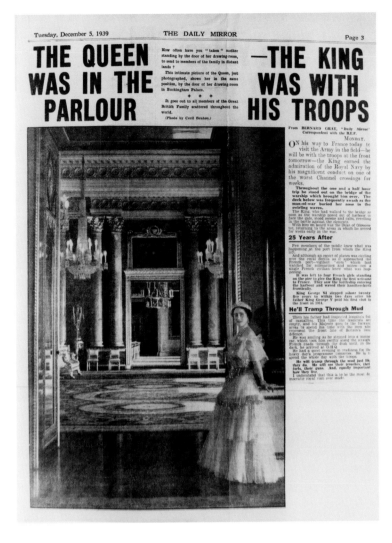

Fig. 20
'The Queen was in the Parlour – The King was with the Troops',
Daily Mirror (5 December 1939)
V&A: PH.1746–1987

diaphanous frills of her gown, electric light illuminates her face.

By 1939, an 8 x 10 inch plate camera had replaced Beaton's original Kodak No. 3A, and it was fitted with the same lens (or so he was told) that was used by Steichen. Beaton had initially been reluctant to purchase the plate camera, but was convinced to do so in the early 1930s by Mr Condé Nast, who assured him that the large plates and superior lens would produce better effects.

In addition to the plate camera, Beaton took a Rolleiflex to the first sitting with the Queen, a camera to which George Hoyningen-Huene (1900–68), another *Vogue* photographer, had first introduced him. At all future royal sittings, Beaton would continue to use both cameras, finding the small, portable Rolleiflex particularly useful in the intervals while the cumbersome plate camera was being repositioned or reloaded.

Princess Elizabeth

The combination of humanity and splendour that Beaton portrayed in his 1939 portraits of the Queen Consort, and later King George VI and the two Princesses, Elizabeth and Margaret, shaped the world's perception of the British royal family during the Second World War. In December 1939, two months after the outbreak of war, Beaton's photographs of the Queen were first published in the press, appearing in newspapers as far away as Australia and India (fig. 19). The day before the images were released, the *Daily Sketch* announced: 'To-morrow the Daily Sketch will publish wonderful pictures of the Queen, taken specially by Mr Cecil Beaton at Buckingham Palace. These pictures will be treasured in hundreds of thousands of homes throughout Britain and the Empire. Make sure of them by ordering your Daily Sketch from your newsagent today.'[22] The newspaper encouraged readers to display the royal portraits by printing elaborate picture frames around them.[23]

The photographs presented a sense of continuity with pre-war Britain that became all the more compelling during this turbulent period, as the images came to signify the magnificence of Britain, its Empire, and a seemingly unshakable, glorious monarchy. The grandeur of the settings and the Queen's splendid attire did not prevent the newspapers from emphasizing the link between the royal family and the millions of families facing dark times. In the text accompanying a Beaton photograph (fig. 20), one *Daily Mirror* reporter described the Queen as mother to all Britons:

How often have you 'taken' mother standing by the door of her drawing-room, to send to members of the family in distant lands?

BUCKINGHAM PALACE, S.W.1.

December 13th. 1939.

Dear Mr. Beaton,

> The Queen desires me to send you
these six photographs.

> You will see that Her Majesty has
placed on their backs a number in red, in
order to identify them, and it would be kind
of you if you would make all *note* these, so as to
facilitate fresh orders when this should be
desired.

> You will also find, in pencil, the
number of reprints which Her Majesty requires.
Would you be kind enough to complete these,
and return them ~~with the originals~~. *as soon as you conveniently can*

> Yours sincerely,

> *Arthur Penn*

> Acting Private Secretary to The Queen.

*Perhaps you wd return these
originals, as soon as you
have noted requirements*

Cecil Beaton Esq.

Fig. 21
A letter to Cecil Beaton from Arthur Penn, the Queen's Acting
Private Secretary, 13 December 1939

Fig. 22
Beaton's signatures on photographs in the Royal Collection,
1939–43

*This intimate picture of the Queen, just
photographed, shows her in the same
position, by the door of her drawing-room
in Buckingham Palace. It goes out to all
members of the Great British Family scattered
throughout the world.*[24]

Numerous newspapers and magazines drew
parallels between the Queen's personal suffering
and the suffering of other British mothers. Beaton's
portraits of Queen Elizabeth were published in
Tatler on 6 March 1940 alongside an article praising
her compassionate attitude and honesty in sharing
her fears for the safety of her daughters.[25]

As well as being widely circulated through the
press, high-quality prints of Beaton's portraits were
ordered by the Palace to be given as gifts by the
royal family. In a letter to Beaton dated 13 December

1939, the Queen's Acting Private Secretary ordered
numerous prints for this purpose (fig. 21). The
photographs, in varying sizes, were mounted on
card, to which Beaton often added his signature
using a variety of media from fuchsia pink pencil
to red paint, black ink, or an unusual multicoloured
pencil (fig. 22). The card might also be signed by
the royals depicted, before being sent to a private
individual or a public organization, or presented
to a visiting dignitary.

Throughout the war years, the British press
remained hungry for photographs of the royal
family, particularly for those featuring the teenage
Princess Elizabeth, first in line to the throne, and
her younger sister, Margaret Rose (1930–2002).
The British society magazine *Queen* suggested
that the French public were equally eager for
new royal portraits:

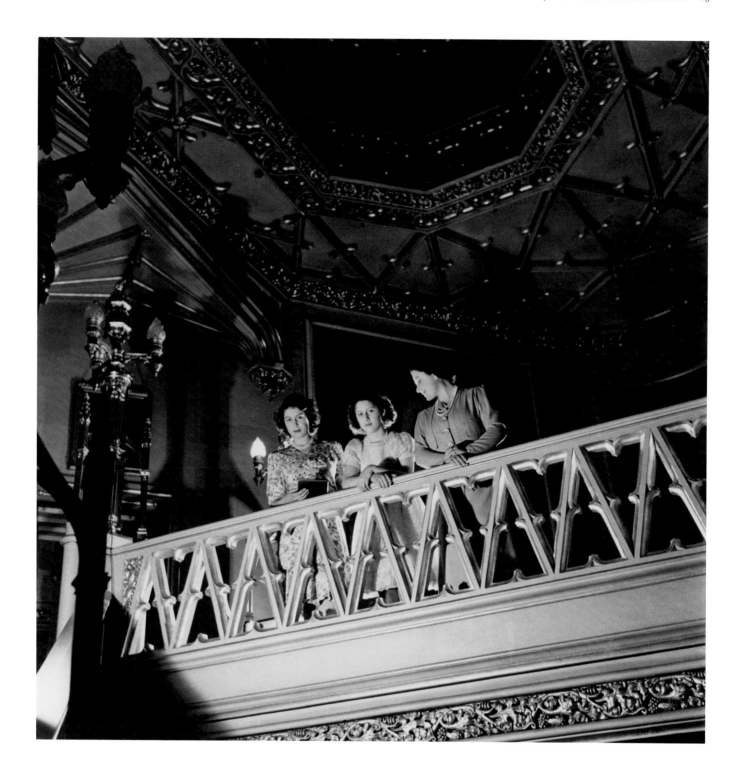

Fig. 23
Cecil Beaton, Portrait of Princess Elizabeth, Princess
Margaret and Queen Elizabeth, November 1943
V&A: PH.206–1987

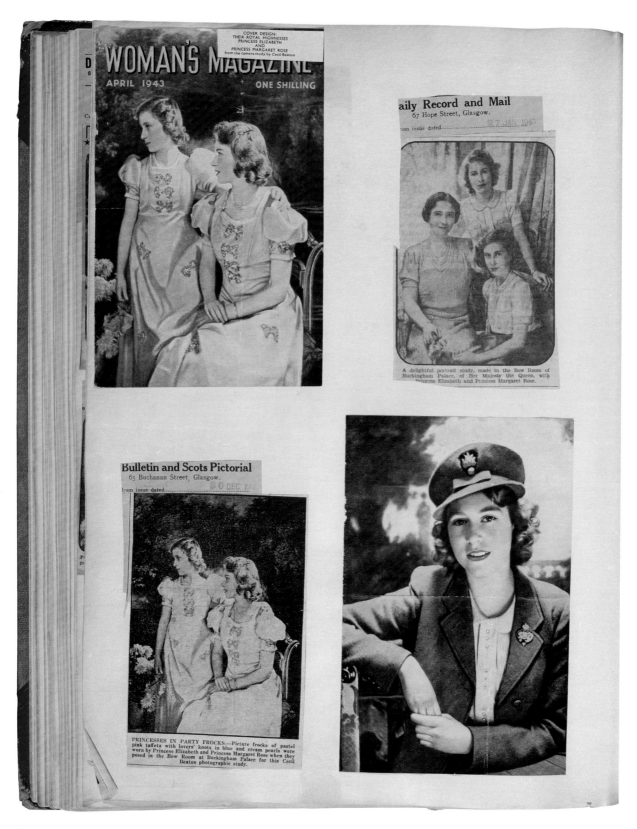

Fig. 24
Page from one of Cecil Beaton's many scrapbooks, containing press cuttings
of his black and white and hand-tinted royal portraits of the 1940s

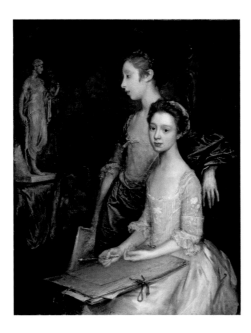

Fig. 25
Thomas Gainsborough, *The Artist's Daughters,*
Molly and Peggy, c.1763–4

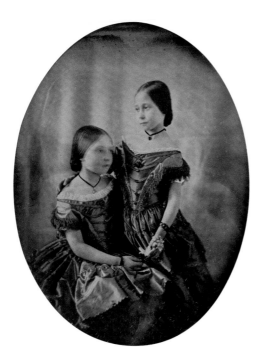

Fig. 26
Theodore Brunell, *Princess Victoria*
and Princess Alice, 1852

The people of France have never forgotten the
visit of King George and Queen Elizabeth to
their country, with its underlying significance
of entente cordiale, *and stories of Her Majesty's*
thoughtfulness and care for men in the Army,
for their dependents, for evacuated children,
and so on are always being repeated in peasant
households. To have a portrait of 'the kind and
beautiful English Queen', even though it is only
one torn from a newspaper, is a great joy to
the families of soldier folk in France.

What the French women would like now
are portraits of Princess Elizabeth and Princess
Margaret, of whom they have heard so much,
and of whose knitting and other efforts to help
the men in the Army they are never tired of
talking. We have seen very little of the Princesses
for such a long time that new pictures of them
would be very much appreciated by everybody.[26]

Princess Elizabeth first sat for Beaton in October
1942, as part of a family sitting with the First Lady
of the United States, Mrs Franklin Roosevelt. The
Princesses spent much of the war at Windsor Castle
in Berkshire, but returned to Buckingham Palace
for Mrs Roosevelt's visit. For Beaton, the sitting
proved a challenging one; he wrote of his quest for
originality and his desire to produce a 'composition
that is not merely a pastiche of the past'.[27]

The 1942 portraits were intended to show the
ordinariness of the royal family, who, like other
Britons, experienced food rationing and collected
clothing coupons throughout the war. The
photographs therefore lack the magnificence of
the earlier fairytale scenes, though the influence
of Gainsborough is still apparent (pls 1–6). As Sir
Roy Strong has noted, an image of the two
Princesses wearing matching pink silk dresses,
decorated with bows made of tiny blue pearls,
was inspired by Gainsborough's portrait of his
daughters, Molly and Peggy (*c.*1763–4; figs 24
and 25).[28] The photograph of the sisters is also
reminiscent of a tender image by Theodore Brunell
(*c.*1822–61) made in 1852, of Victoria, Princess Royal
and her sister Princess Alice in identical dresses
(fig. 26). Although the pose echoes that of
Gainsborough's daughters, Beaton employed a

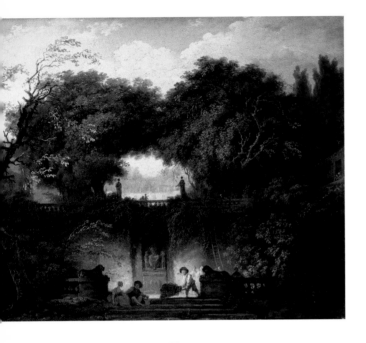

Fig. 27
Jean-Honoré Fragonard, *Le petit parc*, *c.*1762

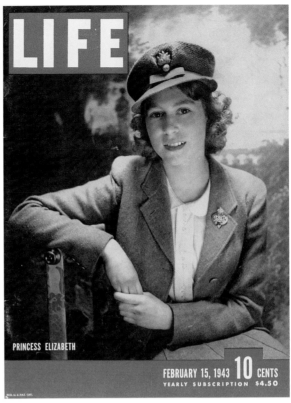

Fig. 28
Princess Elizabeth, *Life* (15 February 1943)

backdrop based on a French rococo painting of the same period: *Le petit parc* by Fragonard (*c.*1762; fig. 27).

In other portraits from this sitting, a smiling Princess Elizabeth sits alone in front of the same backdrop (fig. 28 and pl. 5). In February 1942, her father had bestowed on her the role of Colonel-in-Chief of the Grenadier Guards. She was aged just 16 and it was the first time in history that a woman had been made Colonel-in-Chief of the senior regiment of the Foot Guards. The Princess proudly wears the insignia of the regiment: a grenade on her cap and a diamond brooch of the regimental badge, given to her by the guardsmen and officers of the regiment. An inspection of the regiment, on 21 April 1942, was the Princess's first public engagement and the Grenadier Guards used a

portrait from her sitting with Beaton on their 1942 Christmas card, accompanied by these words from the Princess: 'It is a great honour and privilege to have been appointed Colonel of the Grenadier Guards and I shall do all in my power to uphold and foster the great traditions of the regiment which I have already learned to love.'[29]

Between 1940 and 1944, Beaton worked for the British Ministry of Information, travelling over 100,000 miles and producing 50,000 images of war. He excelled at this new and demanding work and the results were dramatically different to all he had done before. Overseas war photography led him to meet and photograph foreign royalty, such as the seven-year-old King Faisal II of Iraq (1935–58), and Queen Fawzia (b.1921), the beautiful wife of the Shah of Iran.

His portraits of the British royal family continued to be published throughout the British Empire and projected a mood of stability and optimism among the many thousands of war photographs. After the publication of one portrait, a reader from Manchester was moved to write to the *Daily Sketch* in January 1943: 'Thank you for the picture of our princesses. It is refreshing in these days of constant war pictures. Nevertheless it is itself a war picture, because it is an inspiration and it will be treasured for its beauty and its message in thousands of British homes.'[30]

Just as the royal family was not exempt from wartime rationing, neither could Buckingham Palace itself escape the frequent and devastating London bombings. In August 1940, a bomb fell in the Palace grounds, an event that, in Beaton's words, made 'the suffering of the East Enders seem a little less in that they are not alone in their misery.'[31] During the Blitz, the Palace endured nine direct hits. Beaton recorded the damage with his Rolleiflex (figs 29 and 30): a solemn sky and leafless trees are reflected in the stagnant water of a half-empty swimming pool, and broken stone slabs and fragments of ionic columns lay on the ground. Inside the Palace, scaffolding supports the damaged ceilings and the shelves are bare where once they displayed precious silver and porcelain.

Princess Elizabeth matured during the long years of war and her official duties increased. She was made President of the National Society for the Prevention of Cruelty to Children and of the Queen Elizabeth Hospital for Children in Hackney. In February 1945, she joined the Auxiliary Territorial Service and trained as a mechanic and driver, reaching the rank of Junior Commander.

In November 1943, Beaton was invited to photograph the family at Windsor Castle (fig. 23). His photographs of Princess Elizabeth were released the following April to mark her 18th birthday. The Princess, who had been a girl when the war began, now appeared as a young lady. Wearing a simple, knee-length floral dress, she stands alone and thoughtful beside the gothic staircase at Windsor Castle, a sculpture of the boy King Edward VI (1537–53) behind her (pl. 9). Beaton

later wrote of the Princess's aura and the qualities that he struggled to capture with his camera:

Princess Elizabeth's easy charm, like her mother's, does not carry across in her photographs, and each time one sees her one is delighted to find how much more serene, magnetic, and at the same time meltingly sympathetic she is than one had imagined … One misses, even in colour photographs, the effect of the dazzlingly fresh complexion, the clear regard from the glass-blue eyes, and the gentle, all-pervading sweetness of her smile.[32]

As the war came to an end, Beaton returned to Buckingham Palace for another sitting in which he revived the splendour and allure of his earlier portraits. His new photographs of Princess Elizabeth, published in February 1946, evoked the same dreamy atmosphere found in his portraits of her mother, made before the horrors of the war had begun. Not only does Princess Elizabeth pose in front of the same Fragonard backdrop used in 1939, but she also wears one of the Queen's pre-war dresses (pls 10 and 11). Glittering blue butterflies float across the delicate fabric embroidered in rose and gold, an exquisite example of couturier Norman Hartnell's romantic designs.

The outline of the dress was retouched to create a gentle curve and the hair was likewise neatened up (pl. 10). Retouching was a vital stage in the process of creating the perfect royal portrait. This delicate task was carried out by assistants Miss Bell and, later, Wendy Saunders, who under Beaton's instruction often made subtle changes – defining the eyelashes and lips, smoothing wrinkles and waistlines.[33]

Wearing a delicate star-patterned dress, Princess Elizabeth posed against another elaborate backdrop (pl. 12), a winter scene painted in the style of Rex Whistler, a close friend of Beaton's since university, who was killed fighting in 1944. It has been suggested that the portrait of the Princess clad in a gossamer gown beside a frozen lake was intended to show her as the harbinger of spring, the herald of a new beginning.[34]

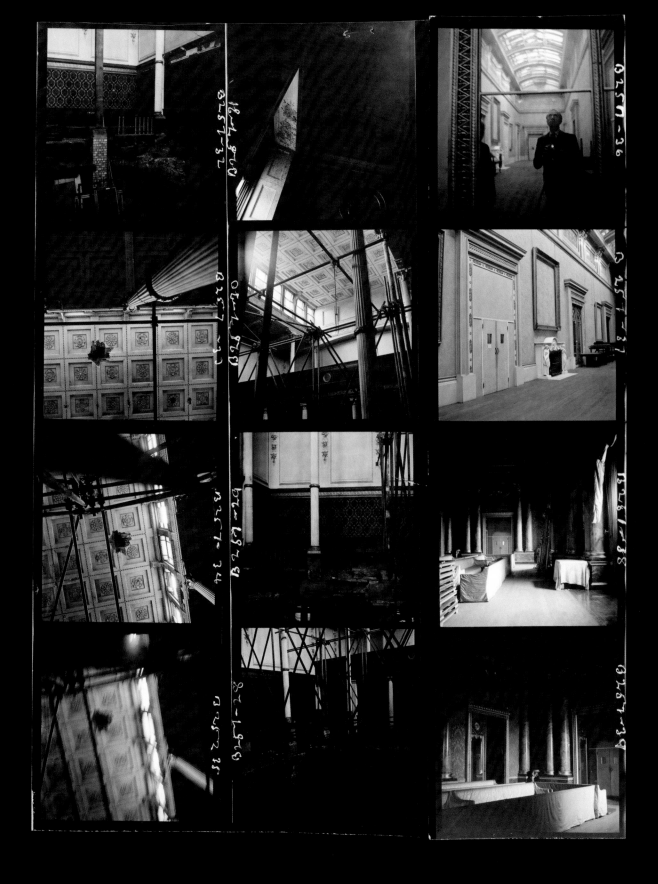

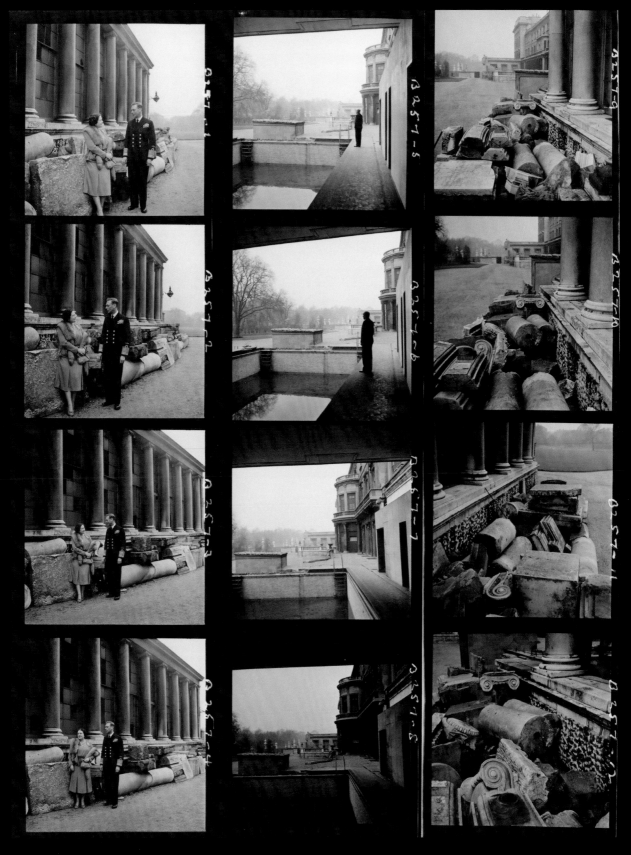

The Coronation

On the morning of 2 June 1953, three million people lined the streets of London to witness the procession of the Gold State Coach as it carried their new monarch to Westminster Abbey to be crowned Queen Elizabeth II. Waving flags and cheering wildly, the crowds showed their support for the Queen, undeterred by the pouring rain. Millions more watched the crowning of Britain's youngest sovereign since Queen Victoria on new television sets. Beaton described the pomp and splendour of Elizabeth II's Coronation as a 'scene of almost Byzantine magnificence'.[35]

The country was still suffering the aftermath of the Second World War when King George VI died in 1952 at the age of 56. The Coronation of his daughter was seen as representing the beginning of a new age, a time for optimism and innovation that the press termed 'the new Elizabethan era'. Winston Churchill eloquently voiced the feelings that the Queen engendered in so many, describing

her on Coronation day as a metaphorical guardian angel: 'the gleaming figure whom Providence has brought to us in times when the present is hard and the future veiled'.[36]

By 1953 Beaton had photographed royalty on more than 30 occasions, but he did not expect to be accorded the honour of taking the Coronation photographs. Upon being invited to do so, he expressed in his diary his feelings of joy and gratitude towards his champion the Queen Mother:

Have been wondering if my day as photographer at the Palace is over. Baron, a most unexpected friend of Prince Philip's, has been taking all the recent pictures, so the call saying the Queen wanted me to do her personal Coronation photographs comes as an enormous relief. Another lease of life extended to me in my photographic career. 'Would you please not tell anyone about it yet as, when the news gets out, so many people will ring up to know why they aren't being asked, and the Queen wants you.'

The same night that this message was relayed to me, at a ball at the American Embassy, I saw the Queen for a brief moment and thanked her. 'No, I'm very glad you're going to take them,' she said, 'but, by the time we get through to the photographs, we'll have circles down to here' (to the eye), 'then the court train comes bundling up here, and I'm out to here' (sticks stomach out). 'There are layers upon layers: skirt and mantles and trains.' She spoke like a young, high-spirited girl.

I also had a short opportunity to thank the Queen Mother for what I am sure must have been her help in bringing about this 'coup' for me. She laughed knowingly with one finger high in the air.[37]

Beaton attended the ceremony at Westminster Abbey along with 8,000 other guests, who began arriving at the Abbey at 6am. His grey top hat filled with drawing materials, sandwiches and barley sugars, he sat in a balcony close to the pipes of the great organ recording his impressions of the glorious pageant as it played out in the ancient Abbey. As a theatre designer and artist, he revelled

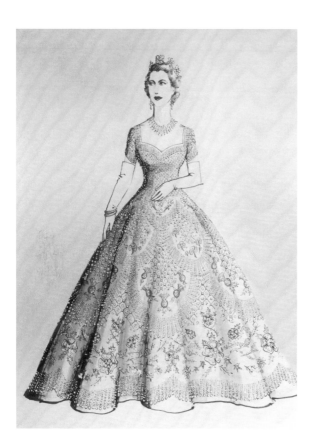

Fig. 31
Norman Hartnell, Design for Queen Elizabeth II's
Coronation dress, 1953

Fig. 32
Cecil Beaton, An assistant
arranges the Queen's
diamond necklace while
her Maids of Honour
look on, 2 June 1953
V&A: PH.1507–1987

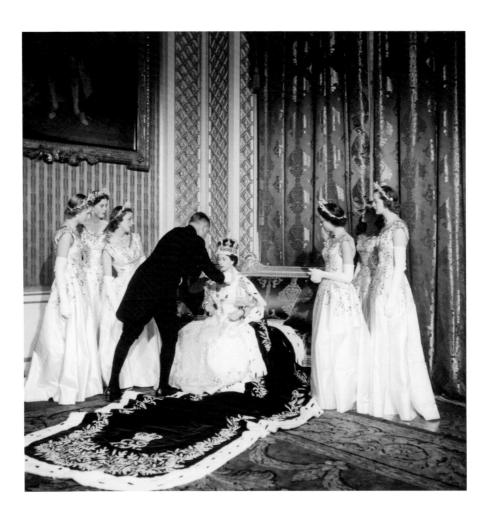

in the theatrical magnificence of the scene and
reported the details in animated prose:

> *This spectacle transcended all preconceived
> notions. The ceremonial seemed to be as fresh
> and inspiring as some great play or musical
> event that was being enacted upon a
> spontaneous impulse of genius. Perhaps it
> was the background of lofty vaulted stone –
> like a silver forest – that made everything
> seem so particularly surprising … The guests
> presented great contrasts in the national and
> traditional garments. The peeresses en bloc
> the most ravishing sight – like a bed of
> auricula-eyed sweet William – in their dark
> red velvet and foam-white, dew-spangled
> with diamonds …*

> *Then, most dramatic and spectacular, at
> the head of her retinue of white, lily-like ladies,
> the Queen. Her cheeks are sugar pink: her hair
> tightly curled around the Victorian diadem
> of precious stones perched straight on her
> brow. Her pink hands are folded meekly on
> the elaborate grandeur of her encrusted skirt;
> she is still a young girl with a demeanour of
> simplicity and humility. Perhaps her mother
> has taught her never to use a superfluous
> gesture. As she walks she allows her heavy
> skirt to swing backwards and forwards in
> a beautiful rhythmic effect.*[38]

The visual coherence of the ceremony was
heightened by the work of Norman Hartnell,
the royal couturier who designed the exquisitely

Coronation.

Feeling very tensed & highly strung in the face of what I had to go through during the following days, I went back to London on Sunday night driven by Roy & Raimund Stirs illuminating one fear; that the [train] journey in the morning would be a nightmare of crowdedness & delay. In the back of the car were several baskets — containing the roses that I had picked for the Queen's pictures. I thought it would be nice if I could have some pictures, in the [winterhalter] manner with real country flowers on a side table — instead of the usual Palace hydrangeas or gladiolis.

Next day I was to set up the backgrounds in the green drawing room — the assistants were asked to be there at 1.30 — I decided to arrive an hour later to find that as I approached my goal down a long labyrinth of corridors that I was getting nearer & nearer to a hubbub of voices — I saw some fur stoles lying on gilt chairs, & knowing how many Royalties were in the Palace that there must be some sort of luncheon in progress — I did not realise that there was an enormous party of the Commonwealth Prime ministers until I halted at the glass doors at the end of the picture gallery, & peeped through the keyhole — luckily I did for if I had proceeded further, with my garden roses wrapped in a bundle under my arm, I should have run into the Queen with but a dozen distinguished old men lined up each side of her for a Times photographer who was letting off a flash. Some Indians present, & lots of dark coloured skins, & jolly jokes were made. The Queen quite obviously elated. The excitement mounting every day, has affected her spirits & she was in excellent mood with a flush of triumph in her cheeks. She is really one person of whom we cannot say that she has an inferiority complex. She is humble & meek in a proud way, but she knows she is delightful & charming, young & gay, & her eyes have developed a radiance.

She was wearing a pale dove fawn coloured dress — & a handbag to match, her hair curled like a girl's for a party. The photographer asked another one more please — another one she repeated in her high fluty voice — giggles

Fig. 33
Extract from Cecil Beaton's diary describing the preparations for the Coronation

laughter - the dark skinned men stood still - a hour as the flash
light went off & the group dispersed to the big Music Room where
a large concourse was smoking cigarettes, & cigars. Churchill standing
with his legs apart, Duchess of Devonshire head thrust forward &
earnest, the Princess too _ also earnest henlike head pop eager & cigarette
smoke exhaled. I wandered into the peer Drawingroom & kept having
an occasional glimpse at the scene from behind a huge set piece of
flowers that constance fry must have created for the occasion - the
palace was in grande tenue 'o a great mass of Hydrangeas, rubber
plants & sweetpeas were around the rooms. I felt that this was the
servants view of Grand life - How conventionally is a pattern everyone
behaved, forced smiles that were real, hearty curtseys, silly jokes that
always succeed, the Duke of Windsor his eyes screwed up feeling safe
in the proximity of Dickie Mountbatten. the slumming grosvenors
with Indians, the Indians grosvenors, a clipped birdlike pleasantries.
It all reminded me very much of Government House life, this was India,
this was formality - Very impressive if you were outside looking in, but
once you were in, & had to remain in oh how infinitely boring - I was
a little surprised when Martin Charteris, the Queens Private Secretary
said to me - Oh good you're here - now so I can give you the information
about dinner tomorrow at our house - we're going to be about 30 -
Koestler is our Star - & we're going to roll up the carpet & dance till
grumfbrave'."

 My poor electricians & assistants had - 2 hours wait before
they were allowed upstairs again - We worked desperately hard &
late to get the backgrounds in place - I cannot too feared with the
arrangements & a little unnerved - But sometimes things go well like the
last moment. the canvas awnings that have been put up started during the blitz
to beat up & down & the rain came down in angry gusts - Surely it couldn't
be cruel enough to rain on the Day of Coronation - Meanwhile
the wind blew, the words outside dispersed o in desperation sheltered in
the afternoon glands - It would be too cruel if the weather were
to continue like this - Meanwhile there was a cold -setting up-, & my
legs started to ache in real earnest. the unaccustomed standing
about can be a great strain - & it was a bad augury

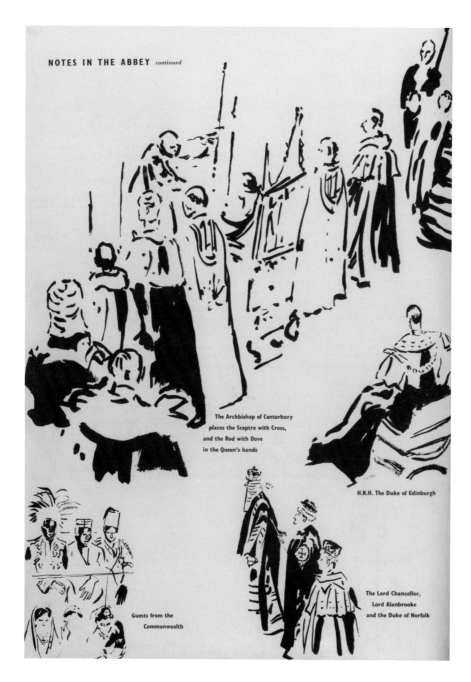

NOTES IN THE ABBEY *continued*

The Archbishop of Canterbury
places the Sceptre with Cross,
and the Rod with Dove
in the Queen's hands

H.R.H. The Duke of Edinburgh

Guests from the
Commonwealth

The Lord Chancellor,
Lord Alanbrooke
and the Duke of Norfolk

Figs 34 and 35
Cecil Beaton, drawings
made during the Coronation
ceremony, *Vogue* (July 1953)

embroidered satin Coronation dress (fig. 31) and
the dresses worn by the Queen Mother, Princess
Margaret, Princess Alexandra, the Duchess of Kent
and the six Maids of Honour. Like Beaton, Hartnell
had designed for the theatre and film and was thus
skilled at creating a splendid tableau for the 'royal
crowd sequence' of the Coronation.[39]

In spare black ink drawings, Beaton documented
some of the most important individuals and
poignant moments of the ceremony: guests from
the Commonwealth, the Dean of Westminster
and the Lord Chancellor, as well as the moment
that the Archbishop of Canterbury placed the Rod
and Sceptre in the Queen's hands (figs 34 and 35).

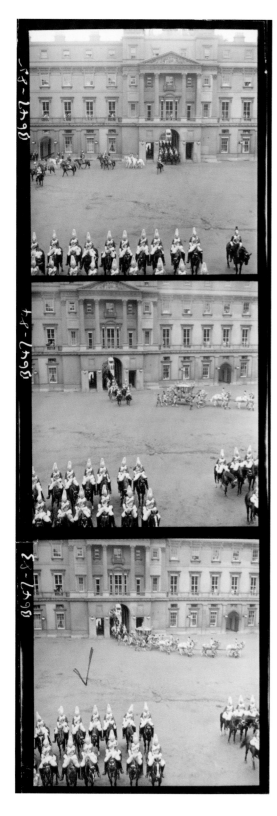

Fig. 36
Cecil Beaton, Contact sheet showing the return of the
Gold State Coach to Buckingham Palace, 2 June 1953
V&A: PH.1498–1987

After the Coronation, Beaton rushed to Buckingham
Palace in time to photograph, from a balcony in the
inner courtyard, the return of the Queen (fig. 36):

> *Every window framed the faces of the Palace
> servants, and a group of them raised a
> tremendous cheer as the Queen Mother came
> back, waving and smiling as fresh as a field
> flower. Then, to the sound of distant roars,
> drawn by eight grey horses the bronze gold
> State Coach, with its Cipriano paintings
> and dark-strawberry padded silk, bowled
> through the central arch and back to home.*[40]

The most important sitting of Beaton's career
necessitated even greater advance planning and
exertion than those that had come before. He
wisely employed the help of his friend Patrick
Matthews, the experienced managing director of
Vogue Studios, who arranged a team of technicians
and electricians. Even Beaton's sister Baba was
enlisted 'to help arrange the trains'.[41] A photograph
snapped by Matthews reveals Beaton and his
colleagues amid the studio lights and tripods,
poised to adjust a lamp or reload a camera at a
moment's notice (fig. 37). Assistants had set up
the lights and backdrops in the Green Drawing
Room at the Palace the day before the Coronation.
Two backdrops were used: one depicting a view
of Westminster Abbey from the river (fig. 38) and
another of the interior of the Henry VII Lady
Chapel at the Abbey, with its unique pendant
fan vault ceiling.[42] The latter was reserved for the
portraits of the Queen alone (fig. 42, pls 16 and 19).
Richard Colville, the Queen's then Press Secretary,
had supplied a list of all the royal individuals and
groups that Beaton was to photograph. While the
Queen posed in the Throne Room for photographers
from *The Times*, Beaton began by photographing
senior royals, including the Duke and Duchess of
Kent (pl. 26), Princess Margaret and the Queen
Mother (pl. 27), whose genuine smile and serenity
calmed the apprehensive photographer:

> *All at once, and because of her, I was enjoying
> my work. Prince Charles and Princess Anne*

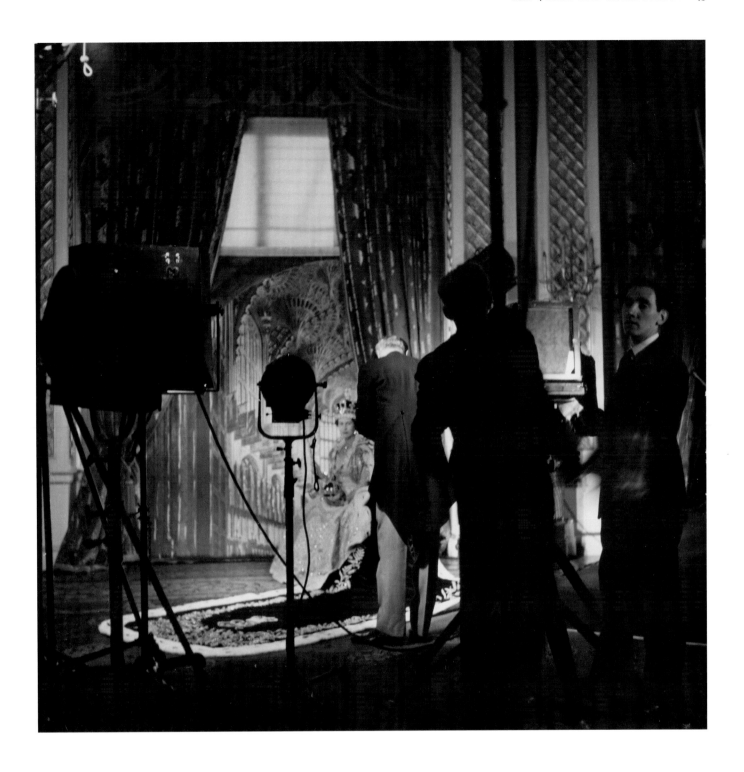

Fig. 37
Patrick Matthews, Cecil Beaton and assistants amid studio lights
and photographic equipment, Buckingham Palace, 2 June 1953
V&A: PH.579–1987

Fig. 38
Engraving by Edward Goodall after David Roberts,
View of the Debarkation on Lord Mayor's Day, 1844

*were buzzing about in the wildest excitement
and would not keep still for a moment. The
Queen Mother anchored them in her arms,
put her head down to kiss Prince Charles's
hair, and made a terrific picture.*[43]

In contrast to the spontaneity of the photographs
of the Queen Mother and her grandchildren, in
his powerful images of the new Queen Beaton
conformed more strictly to the traditions of painted
Coronation portraits. In all of his Coronation day
portraits, Elizabeth II wears the Imperial State
Crown, a replica of the crown made for Queen
Victoria's Coronation. Among the precious gems
set into the Crown are a sapphire from the ring
of Edward the Confessor, the Black Prince's ruby
and the Lesser Star of Africa, one of the nine

enormous diamonds cut from the Cullinan
Diamond. The Cullinan Diamond had been
presented as a birthday gift to King Edward VII
in 1905. The largest stone cut from it, the Great
Star of Africa, was added to the Sceptre with
the Cross, which was originally made for the
Coronation of King Charles II in 1661. The Queen
holds the Sceptre with the Cross in her right
hand, balanced by the Orb in her left. Adorned
with pearls, rubies, sapphires, emeralds and a
huge amethyst, the Orb was likewise made for
Charles II. On her right hand, the Queen wears
the Coronation Ring, a symbol that the Sovereign
is 'wedded' to the state. On both wrists are the
Armills (golden bracelets), signifying sincerity
and wisdom, and presented to the Queen for the
Coronation by the Governments of the United

Kingdom, Canada, Australia, New Zealand, South Africa, Pakistan, Ceylon and Southern Rhodesia.

The portraits of the Queen posed against the backdrop of the Abbey's grand interior, framed by swathes of opulent fabric, combine elements from both George Hayter's initial and revised compositions of the Coronation portrait of Queen Victoria (1840). The original version, preserved in the form of an engraving by H.T. Ryall, includes an interior view of Westminster Abbey, but Hayter later repainted the background, altering it to depict a royal canopy (figs 39 and 40).

In one photograph, the Queen turns her head to gaze confidently at the viewer, evoking the powerful portrait of Charles II by John Michael Wright (figs 41 and 42). In another, the Queen smiles broadly, a genuine and joyous expression rarely depicted in previous Coronation portraits (pl. 21). In several photographs the figure of the Queen appears to glow, 'the strangely transfiguring radiance that encircles those who occupy a throne',[44] while in others a more dramatic light illuminates her profile, causing her eyes and jewels to sparkle.

Unlike his painter predecessors, who were granted numerous sittings in which to complete a single portrait, Beaton had just a few short minutes to create his portraits of Elizabeth II. Nonetheless, his photographs convey a greater atmosphere of splendour than the official State Portrait *Queen Elizabeth II in Coronation Robes* (1953–4) by Herbert James Gunn (fig. 43). In Gunn's painting, the Queen wears the Diadem while the Imperial State Crown is positioned on a table beside her, in keeping with the Coronation portraits of her parents by Sir Gerald Kelly and that of her grandfather, King George V, by Sir Luke Fildes.

The Coronation portraits were published in the world's press and supplied as prints for the royal family for use as official gifts. In a letter to Prince Philip (b.1921), Martin Charteris, the Queen's Assistant Private Secretary, notes which

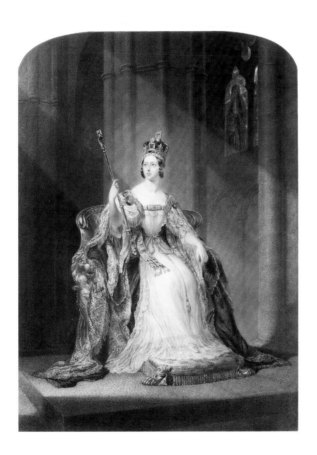

Fig. 39
Engraving by H.T. Ryall, after George Hayter, *Queen Victoria*, 1840

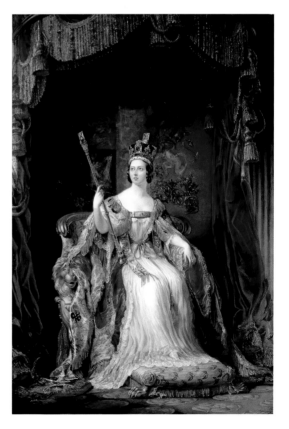

Fig. 40
George Hayter, *Queen Victoria*, 1840

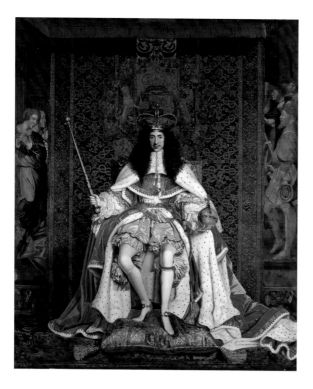

Fig. 41
John Michael Wright, *Charles II*, c.1661–2

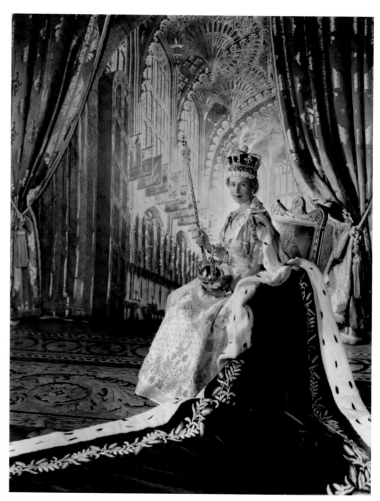

Fig. 42
Cecil Beaton, Portrait of Queen Elizabeth II, 2 June 1953
V&A: PH.1550–1987

photographs the Queen selected as gifts for three
distinct groups: a portrait of the Queen and Prince
Philip together, for the royal family and members
of Prince Philip's family (pl. 17); the Queen flanked
by her six Maids of Honour, for the Maids of
Honour (pl. 29); and the portrait of the Queen
seated alone holding the Orb and Sceptre, for
the important guests, such as Commonwealth
representatives (pl. 16).[45]

In selecting six Maids of Honour, instead
of pages, to bear her 20-yard-long velvet train
during the Coronation ceremony, Elizabeth II

had followed the precedent of Queen Victoria.[46]
Beaton took his photographs of the Queen with
her Maids of Honour late in the afternoon after
completing the majority of the other portraits.
Lady Jane Vane-Tempest-Stewart (now The Lady
Rayne) would later recall the mood:

*We were all exhausted – the Queen most of all I
should imagine. We had all been up since 5am
and it was then about 4pm. Cecil Beaton was
most particular about placing the six of us
Maids of Honour around the Queen in the order*

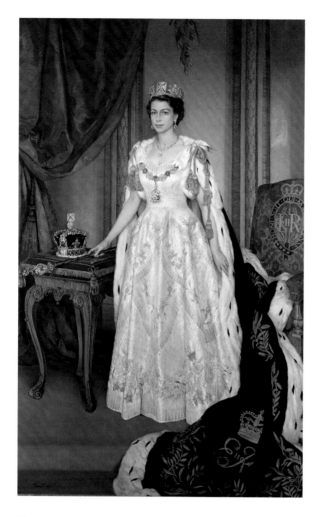

Fig. 43
Herbert James Gunn, *Queen Elizabeth II
in Coronation Robes*, 1953–4

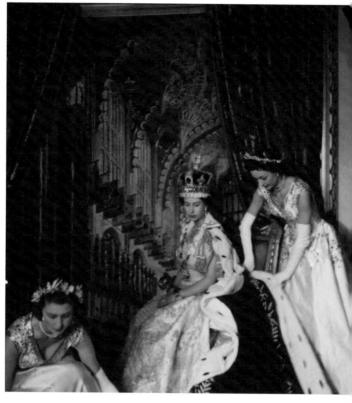

Fig. 44
Cecil Beaton, Candid photograph of the Maids of Honour
arranging the Queen's robes, 2 June 1953
V&A: PH.1802–1987

we stood in the Abbey – the smallest ones in the front nearest the Queen. She seemed very tiny and fragile but rose to the occasion magnificently.[47]

When the photographic session ended, there was still much work to be done in processing the films. At three o'clock the following morning, Beaton telephoned the studio to hear that the pictures were a triumph. A few hours later, he rushed to the studio to select the best prints, which were sent to the Palace for official approval. By noon, several photographs had been selected by the

Queen for publication and Beaton's assistants spent the days following supplying the press with the requisite number of pictures. At the end of the week, the elated photographer returned to his country home in Wiltshire:

Only by a fraction of a minute did I catch the Friday evening train to make my getaway to the retreat of the country. I bought an evening paper at Waterloo Station and one of my pictures of the Queen was printed across the front page of the Evening News.[48]

The Next Generation

Five years prior to her Coronation, Princess Elizabeth became a mother, giving birth to Prince Charles Philip Arthur George on 14 November 1948. At her mother's suggestion, she chose Beaton to photograph her newborn son. It proved to be a highly successful sitting, as Beaton recounted in his diary:

> *Happily summoned to the Palace to take the first long-awaited photographs of the heir to the throne. Prince Charles, as he is to be named, was an obedient sitter. He interrupted a long, contented sleep to do my bidding and open his blue eyes to stare long and wonderingly into the camera lens, the beginning of a lifetime in the glare of public duty.*[49]

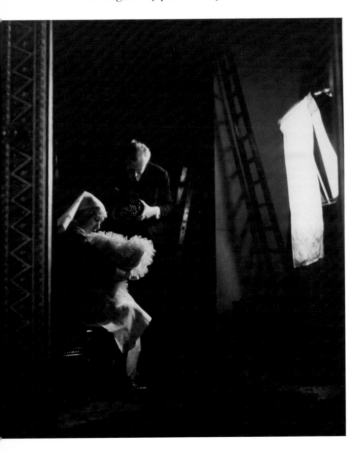

Fig. 45
Patrick Matthews, Cecil Beaton photographing Sister Rowe and Prince Charles, 1948
V&A: PH.1464–1987

Beaton would go on to take photographs commemorating the births of all Elizabeth's children: Princess Anne in 1950, Prince Andrew in 1960 and Prince Edward in 1964. His tender portraits of the young royal family projected an image of 'ordinary' life and depicted Elizabeth as an accessible figure to whom any parent could relate. In contrast to the sparkling Coronation regalia of 1953 or the magnificent Garter Robes worn for the 1955 sitting, the clothes she wore for the family portraits were elegant but simple.

Beaton photographed the baby Prince Charles on 13 December 1948, two days before his christening. He commissioned a new backdrop for the occasion, which his assistants installed in the gold and ivory-coloured Music Room at Buckingham Palace. Beaton captured the lively baby using the large 8 x 10 inch and smaller Rolleiflex cameras, loaded with colour and black and white film. He desribed the momentous occasion in his *Photobiography*:

> *I was astonished that a month-old baby should already have so much character, and I felt that the child already bore some resemblance to his grandmother and great-uncle. For so young a child he seemed to have a remarkable range of expression; and I was fascinated by the looks of surprise, disdain, defiance, anger and delight that ran across his minute face.*[50]

The photographer responsible for the portraits commemorating the Prince's christening two days later was less fortunate than Beaton: Charles remained asleep for the duration of the sitting. Those photographs were published in late December, while Beaton's photographs appeared a few days later when several newspapers, keen to print his newest pictures, ignored an embargo that was designed to prevent their publication before 2 January 1949. The first photograph of the sitting was the most widely published: a close-up of the Prince in his chiffon and lace crib, nestled among heart-shaped cushions (pl. 36). In other images, Princess Elizabeth stands beside the cot and gazes dotingly at her son (pl. 35). The press enthused:

The photograph on this page of Princess Elizabeth and her son is not only one of the most charming ever taken, but one of the most radiant studies of a young mother with her baby son. No mother, whether of royal or humble birth, who treasures the first photograph of her child for the memories it bestirs, can look at it unmoved; it has not been said without reason that the most poignant human experience is when a mother gazes on the baby to which she has given birth.[51]

Sister Helen Rowe, the Princess's midwife, known affectionately as Rowie, would attend the births of all four royal children. Patrick Matthews captured the reflection of Beaton, Rolleiflex in hand, as he photographed Sister Rowe cradling the baby Prince (fig. 45). On the same afternoon, Beaton took several colour portraits of the Princess alone, looking graceful in a midnight blue dress (pls 37 and 38).

Princess Anne Elizabeth Alice Louise was born on 15 August 1950 and Beaton photographed her a month later with her mother and brother at Clarence House, the family's home in London until 1953. The Duke of Edinburgh was not present for the sitting, as he was serving with the Royal Navy. Beaton's favourite picture of the day captured the spontaneous moment when the 18-month-old Prince Charles kissed his little sister's cheek (pl. 40): 'it reminded me of the great moment in The Sleeping Beauty ballet'.[52]

Another of the day's most successful portraits shows Princess Elizabeth giving her young son a piggyback (pl. 42), a twentieth-century version of W. & D. Downey's famous 1868 portrait of Princess Alexandra, carrying her first-born daughter Louise (1867–1931) on her back (fig. 46). Downey's portrait was undoubtedly familiar to Beaton; in the 1860s, it became the most popular photograph ever made in England, selling 300,000 copies in carte-de-visite format.

Although Beaton never sold his royal portraits to collectors in the way Downey portraits were sold, the press encouraged the public to cut out and preserve his published portraits of Princess Elizabeth and her young family with headlines

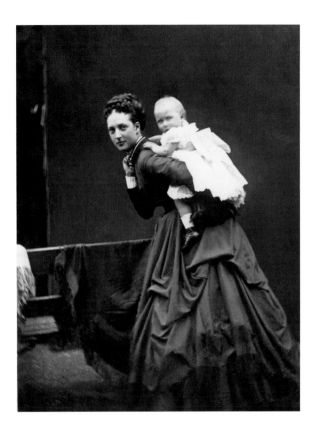

Fig. 46
W. & D. Downey, Princess Alexandra carries her daughter Louise on her back, September 1868

noting their collectability. *The Sunday Graphic and Sunday News* published the portrait of Prince Charles and Princess Anne on its cover (pl. 40), with the title 'Baby Princess ... A souvenir', and the caption below, 'The Sunday Graphic proudly presents this enchanting study of Prince Charles and Princess Anne, from a print specially made for you by Cecil Beaton'.[53]

Just as readers had been compelled to write to the newspapers in response to Beaton's wartime portraits of Princess Elizabeth and Princess Margaret, they were moved by the intimacy of the baby portraits. A Winifred E. Nelson wrote to one newspaper: 'Once again I should like to say "Thank you" for your Page One picture last week – the picture of Prince Charles with his baby sister, which so many have been waiting so long to see. In my opinion Cecil Beaton surpassed all expectation.'[54]

Fig. 47
Cecil Beaton, Portrait of Queen
Elizabeth II and Prince Edward,
May 1964
V&A: PH.230–1987

Prince Andrew Albert Christian Edward
(b. 19 February 1960) and Prince Edward Antony
Richard Louis (b. 10 March 1964) were the first
children to be born to a ruling monarch since
Queen Victoria's reign. On learning she was to
have a third child, Queen Elizabeth wrote to Sister
Rowe of her delight, adding: 'The children were
very excited at the news of the baby, especially
Charles, who loves small children.'[55] By 1960, the
royal family wished to project a more accessible,
modern image. Beaton therefore took a new
approach to royal portraiture, abandoning his

rococo settings for simple backgrounds,
a choice perhaps inspired by the work of Irving
Penn (1917–2009), a fellow *Vogue* photographer
and leading American portraitist, whom Beaton
greatly admired. Penn was among the first to use
such backdrops and his 1950 portrait of Beaton
exemplifies his bold, stripped-back aesthetic and
masterful use of studio lighting (fig. 55). Beaton
also photographed Penn and, though their styles
differed greatly, the American was impressed
by the Englishman's versatility and attitude,
writing in 1950:

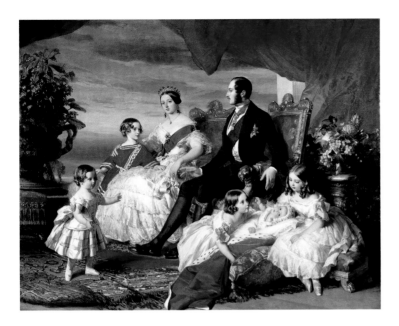

Fig. 48
Franz Xaver Winterhalter, *The Royal Family*, 1846

I am fascinated by your variety of results from a single sitting. I envy you that ability. You bring something to a conclusion and go on to something else ... I left your sitting feeling very different from you. I thought once that you must be making fun of me since the instructions you gave me were almost directly opposite to the things I say during a sitting, but in retrospect I realize it was all of a piece – the vague clairvoyance, the gentleness of not meeting the subject too head-on, the charmingly smooth relationship you have with your assistants.[56]

Despite a new photographic approach, Beaton did not entirely forget his heroes Gainsborough and Winterhalter, and in the portrait of the Queen and Prince Andrew standing beside Prince Edward's crib (pl. 49), the pose of the baby echoes that of the infant Princess Helena in Winterhalter's painting *The Royal Family* of 1846 (fig. 48).[57] For Beaton the sitting was a difficult occasion, and he wrote in his diary: 'Daylight hardly existed ... I got very impatient and felt that the odds were

ganging up against me.'[58] When faced with such problems, Beaton could rely on the help of his dedicated assistants.

Geoffrey Sawyer (b.1933) accompanied Beaton to many sittings in the 1950s and '60s, and continued to work with him until Beaton's death in 1980. A photographer in his own right, Sawyer studied at the London School of Printing and Graphic Arts (now the London College of Communication) before joining *Vogue* Studios in London as an assistant and printer. It was through *Vogue* that the two photographers met, and when Sawyer opened his own studio in Soho Square, he began developing and printing Beaton's films. Eileen Hose, Beaton's secretary, recalled that Sawyer 'masterminded the intricacies of lighting and other technical essentials. He was thus able to make the prints with the benefit of inside knowledge. He was of great value to Sir Cecil.'[59]

At most royal sittings Beaton would have two or three assistants, whose primary duties were to arrange the backdrops, ladders and tripods, and to reload the cameras. Sawyer engaged the services of a lighting company, Lee Electric, and manipulated the lights in order to produce the desired effects. As he explained: 'The lighting tended to be very soft and gentle. Cecil loved beauty and he could envisage the composition of a particular photograph, and I did my best to supply the technical expertise required to achieve exactly what he wanted.'[60]

By the 1950s, Beaton was so renowned that one writer commented, 'there are some who are convinced that he, together with Daguerre and Julia Margaret Cameron, invented photography.'[61] A year before Prince Edward's birth, Beaton published his first book of royal portraits.[62] Upon receiving a copy of the new book, Queen Elizabeth the Queen Mother wrote to Beaton in praise of the humanity that he portrayed:

My dear Mr Beaton,
It was so kind of you to send me a copy of your wonderful book of portraits of my family, and I do want to thank you for giving me such a charming present, I find it very nostalgic looking through the pages. The years telescope,

*and I suddenly remembered what I felt like
when I wore those pre-war garden party
clothes – all those years ago.*

*It is absolutely fascinating to look back,
and I feel that, as a family, we must be deeply
grateful to you for producing us, as really
quite nice and <u>real</u> people!*

*The photographs are so lovely, and the
whole book marvellously produced.*[63]

'Sparkling Possibilities'

In the 1960s, Beaton continued to work energetically
in all aspects of his career. He spent 10 months in
Hollywood in 1963 designing the film production
and costumes of *My Fair Lady*, starring Audrey
Hepburn, for which he won two Oscars. In
'Swinging London', a new generation of
photographers, led by David Bailey (b.1938),
Terence Donovan (1936–96) and Brian Duffy
(1933–2010), was making waves on the pages of
Vogue and *Harper's Bazaar*. Beaton's photographic
style changed with the times. He began to work
more confidently in colour and captured many
fashionable and creative icons of the era, including
Twiggy, Jean Shrimpton, Mick Jagger and Andy
Warhol. He posed with dancer Rudolf Nureyev for
David Bailey's Box of Pin-ups in 1965 (fig. 49) and
was the subject of a documentary film by Bailey.

In 1968, London's National Portrait Gallery
staged *Beaton Portraits 1928–68*, the first
retrospective of the work of a living photographer
to be held at a national museum in Britain (figs 50
and 51). Sir Roy Strong, the Gallery's dynamic
Director, curated the show, while ballet critic and
exhibition designer Richard Buckle devised the
theatrical installation, comprising 572 photographs
divided into themed rooms, enlivened by music
and incense. The Queen Mother opened the
exhibition, which was an overnight sensation,
drawing 80,000 visitors between November 1968
and March 1969 – a record for the Gallery.

Beaton knew that one of the secrets to longevity
was to adapt to new trends. A few months before
the opening he wrote in his diary that the exhibition
must be 'with it': '[It is] very important I show that
I'm not just a bit of past rococo and the 'Today'
section must be the highlight.'[64] He hoped to

include new photographs of the Queen and
approached Martin Charteris about the possibility.
Charteris wrote to the Queen on 10 October 1968:
'Cecil is anxious to do something different and
wondered if Your Majesty would pose for him in
a simple dress or the Boat Cloak?'[65] The Queen
agreed to wear an Admiral's Boat Cloak of dark
serge fabric. Several other outfits were selected
in advance and a date was set for the sitting at
Buckingham Palace. It was also agreed that Beaton
would take some portraits especially for the new
Channel Islands stamps, to be released in 1969 for
the inauguration of the Jersey Post Office.

Despite over 30 years' experience as a royal
photographer, Beaton still felt apprehensive
beforehand, aware of the tensions that could
arise between sitter and photographer:

> *I suppose I've forgotten that in earlier days I
> would get 'nerves' before an important sitting,
> but certainly this time I felt quite anxious. The
> difficulties are great. Our points of view, our
> tastes are so different. The result is a compromise
> between two people and the fates play a large
> part. One does not know if things will conspire
> against me, or if the sun should shine.*[66]

Before the Queen's arrival, Beaton met with
Charteris to inspect the lights and backdrops
that had been arranged earlier in the day. He
had selected plain white and blue backgrounds,
resolving to be 'stark and clear and bold'.[67] Despite
a faltering start, the sitting proved a triumph:

> *At first the effects of the lights were a disaster.
> Nothing went right. I took pictures to cover up
> my frustration. Each way she turned was worse
> than the last. The lights dead. We tried, in quick
> succession, the footlight on the floor, off, the
> full right light off, nothing came to light. Then
> suddenly she turned to the left and the head
> tilted, and this was the clue to the whole sitting
> – the tilt. I kept up a running conversation,
> trying to be funny, trying to keep the mirth light
> … By now I felt I had started to get something
> and was busy duplicating this one pose that
> I felt had provided the afternoon's solution.*[68]

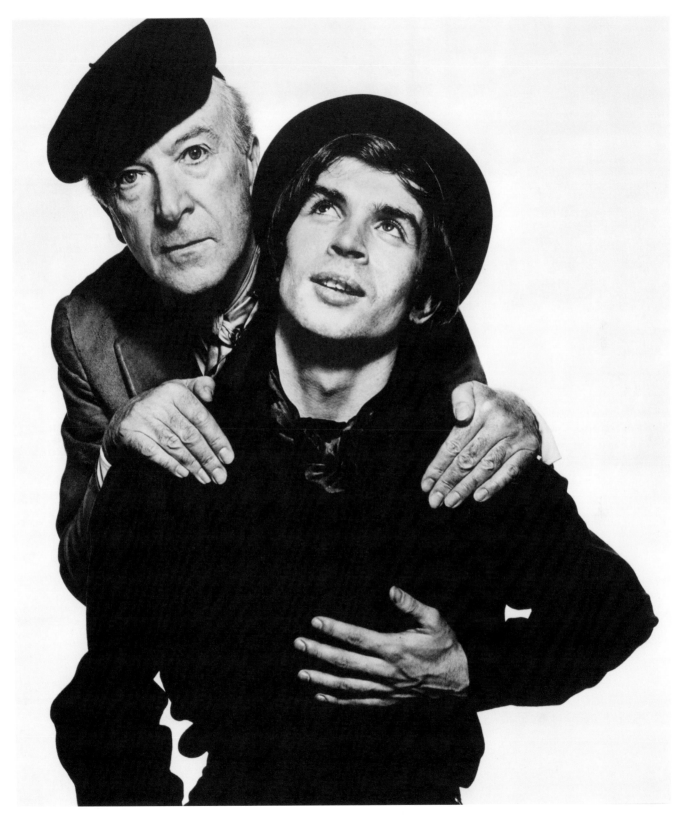

Fig. 49
David Bailey, Portrait of Cecil Beaton and Rudolf Nureyev,
David Bailey's Box of Pin-ups (1965) V&A: E.2047:12–2004

Figs 50 and 51
Installation shots of the exhibition *Beaton Portraits 1928–68*
at the National Portrait Gallery, London, 1968

The contact sheets of the Queen in this pose reveal the subtle movements of the head to left and right (pl. 50); her gaze meets the viewer or settles on a distant point, until the perfect angle is achieved. Beaton labelled his photographs of the Queen wearing the Boat Cloak as 'the poor man's Annigoni',[69] since the pose was based on Pietro Annigoni's portrait of the Queen wearing the Order of the Garter (1954; fig. 52). In the works by both Annigoni and Beaton, the Queen is portrayed as a powerful but ultimately solitary figure. As Annigoni explained: 'I saw her immediately as the Queen who, while dear to the hearts of millions of people whom she loved, was herself alone and far off.'[70]

At the suggestion of Geoffrey Sawyer, Queen Elizabeth II moved to the balcony of an inner courtyard for further portraits, before posing in the Blue Drawing Room and the White Drawing Room. By now Beaton was filled with positivity:

The sun was now shining for the rest of the afternoon and I bade the many assistants bring in our background from the dark cavern and rely on God's glorious daylight. Everywhere were sparkling possibilities. The Queen reappeared in a vivid turquoise-blue dress, the Garter mantle and Queen Mary's pearl and diamond looped tiara.[71]

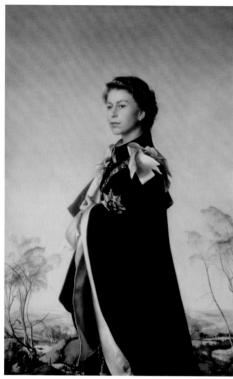

Fig. 52
Pietro Annigoni, *Queen Elizabeth II*, 1954

Fig. 53
British stamp featuring a
portrait of Queen Elizabeth
II by Dorothy Wilding, 1952

Fig. 54
Channel Islands stamps
featuring a portrait
of Queen Elizabeth II
by Cecil Beaton, 1969

Beaton took numerous head-and-shoulders shots of the Queen for the new Channel Islands stamps. Hand-drawn blue lines on Beaton's contact sheet suggest that a simple profile was initially selected (pl. 54), in keeping with the centuries-old precedent for depicting rulers in profile on coins and medals. However, a more flattering three-quarter profile was settled on (fig. 54), following the example of the photographic portrait by Dorothy Wilding that appeared on British stamps between 1952 and 1967 (fig. 53).

When the National Portrait Gallery unveiled the new photographs of the Queen, critics were impressed by the mood of austere magnificence:

An unusually dramatic photograph of the Queen is published today, as she flies to South America on a State visit. In recent years pictures of the Queen have tended to emphasise her motherliness, her friendliness. In her new portrait she is definitely imperious, a forceful and determined monarch – an effect partly produced by the severe lines of the cloak she is wearing. The picture is by that master of the unusual, Cecil Beaton, and is among his work on show at the National Portrait Gallery.[72]

The 1968 portraits were the last Beaton made of Elizabeth II, although he continued to photograph other members of the House of Windsor until November 1979, just two months before his death in 1980. Several photographers had shared the honour of being invited to photograph the Queen – including Marcus Adams, Lisa Sheridan, Dorothy Wilding, Baron, Godfrey Argent, Lord Snowdon and Norman Parkinson – yet few photographed her over such a long and transformative period of her life.

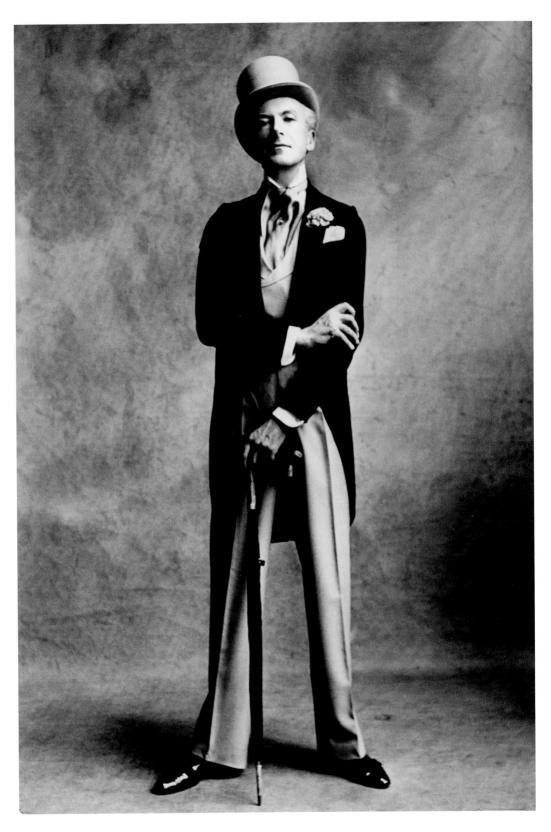

Fig. 55
Irving Penn, Portrait of Cecil Beaton, *c.*1950
V&A: PH.961–1978

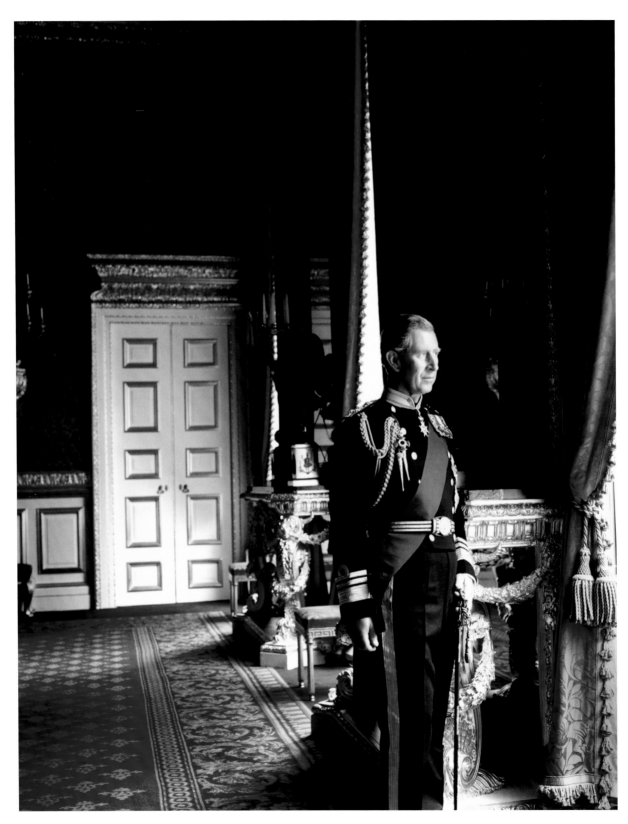

Mario Testino, Portrait of Prince Charles,
St James's Palace, June 2003

Afterword

Mario Testino

WHEN I FIRST ARRIVED in England from Peru, my knowledge of the history of photography was, frankly, rather limited. But my new friends in London knew all about it and I remember noticing that the name 'Beaton' often came up in their conversation. I was very curious to know who this Beaton was and I began to discover his extraordinary career as a photographer. However, I started looking seriously at Cecil Beaton's work in relation to my own only when I began shooting for *Harpers & Queen* in London. Hamish Bowles, who is now European Editor-at-Large of American *Vogue*, had won a competition through the magazine and his prize was to come and edit the fashion pictures for one issue. To my amazement, he too was fascinated by Beaton. That was my first real encounter with a collaborator where Beaton's work would be an inspiration to us both, and I became increasingly fascinated by Beaton's techniques, his theatrical sets and lighting, and his artistic flair. Around that time, we did some more stories together for *Harpers & Queen* and worked with Michael Howells and Patrick Kinmonth who both did the sets, often inspired by Beaton's work. We tried to emulate some of his photographs, like the early pictures of his sisters that he did while he was teaching himself, by using torn and cut paper and rather surprising things such as silver paper and cellophane; or those of Diana Cooper, where he gave her and other English society portrait sitters the glamour of German and American movie stars; or the Queen Mother posed against the real grandeur of the royal palaces, when Beaton was at the height of his powers.

Some years later, I met Kolinka Zinovieff, whose sister Sofka had inherited Faringdon House, an amazing place near Oxford. It had belonged to Lord Berners, the great English eccentric, composer and aesthete. He had all the pigeons dyed different colours, which flew up like a rainbow in front of the eighteenth-century house when you arrived. One day, we were looking in the attic and found all the old photograph albums from the 1930s, and of course in there were Cecil Beaton, the Sitwells, Gertrude Stein and that whole 'set'. I realized seeing those pictures that Beaton was part of a group of friends that shared a way of seeing the world, even though at that time it was probably limited to their rather exclusive version of England. They had a particular aesthetic, a sense of the eccentric and of the surreal; but I realized that it was not just Beaton's vision, it was the creation of a whole collective that egged each other on. I know myself that in life it is a wonderful thing to be surrounded by talented and remarkable people who support, inspire and help you in your work. In one of Beaton's pictures, Lord Berners is sitting in the drawing room at Faringdon, with his white horse standing beside him amongst the sofas and the little chairs and tables. Quite magical, but it came naturally out of the life they were all leading.

It is very hard for me to choose one of Beaton's photographs as my favourite; people always ask which is my favourite piece of my own work. I can never decide, because there are so many different reasons why I might like a picture, and I find it quite hard to define in the work of other photographers too. It is dependent on what I am trying to do in my own work at a particular time. However, I especially like Beaton's early photographs, when he is trying to find out what makes a good picture for him, and his later social and royal portrait photography.

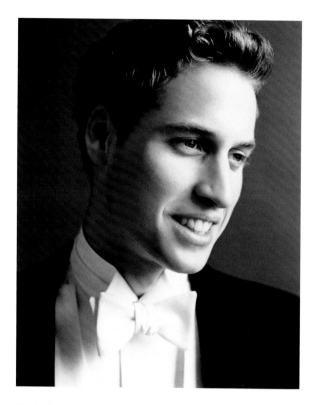

Mario Testino, Portrait of Prince William,
June 2003

Mario Testino, Portrait of Prince Harry,
Highgrove, September 2005

When photographing royalty you obviously have to involve tradition, because your pictures are becoming part of it. You need a particular sense of respect – you cannot just go in and change the course of royal portraiture and make the sitters your own creation, as you might try and do in a fashion photograph – it is more about documenting them and trying to bring some nuance that will be your addition to the portraits that already exist. When I do a fashion photograph, the models are like a blank canvas onto which you can paint anything you want, and you can erase and repaint until you get what you are looking for. It is a totally different project.

Beaton used many different materials when creating his portraits, including props and backdrops that looked back to the traditions of nineteenth-century studio photography. But times have changed and I find that the most magical

photograph occurs when you capture that candid moment that was not prepared or thought of, which seems completely spontaneous. A picture like that makes you feel closer to the person, it removes distance. This in itself is an art. In order to capture those moments, you have to be intimate with the people and completely relaxed. Sometimes the most special thing for me is to see the sitter in their most unprepared, most unstudied way. To achieve this, I do not like to have too many people around, too many lights or materials, because all the time that you spend perfecting them you risk losing that moment.

I think Beaton probably had a closer relationship with the royal family than other photographers of the time and so he had an intimacy that put his work ahead. In order to get his picture, he could speak to them during the sitting in a way that other photographers either

could not or would not. You can see from the expressions on the faces in a Beaton portrait that there is real warmth between them. They are clearly enjoying themselves and the moment. It is this that makes the pictures so alive.

To me, Beaton was more than a photographer: he was a set designer, a dream maker and an artist, so any photograph he took was not just a document of something that existed, but also of something he had created. Even before taking the photograph, there was a lot of thought and imagination put into it and it showed a very particular and personal style, which nobody else could recreate.

I think, as photographers, we are always longing for something that we cannot have, and Beaton recorded a time that was all about dreams. He perfected his images and made his dreams seem real in the process. Somebody once wrote about one of my photographs saying that it looked like an image from the past, when people had the time to contemplate, to evolve and everything was slower. That dreamy quality, as if time is standing still, is something I learned from looking at Beaton's work and often tried to emulate. Today, we do not have time to look at the world like that. In Beaton's images you can feel a stillness, as if there was no real hurry, as if he could say to his sitters 'sit there' and they just sat there for hours until he could make it all perfect and beautiful. The set, the light, the clothes … it is a sort of magic we all long for. In our modern world, everything is fast, from photography to food, but Beaton was the complete opposite. He was like a five-course dinner with amazing friends by candle light.

Mario Testino, Portrait of Prince Charles, Prince William and Prince Harry, Highgrove, 2004

Plates

1

Queen Elizabeth, Princess Elizabeth and Princess Margaret, October 1942
Gelatin silver print, 21.8 × 16.8 cm
V&A: PH.677–1987

2

Princess Elizabeth and Princess Margaret, October 1942

Gelatin silver print, 17.9 × 14.2 cm

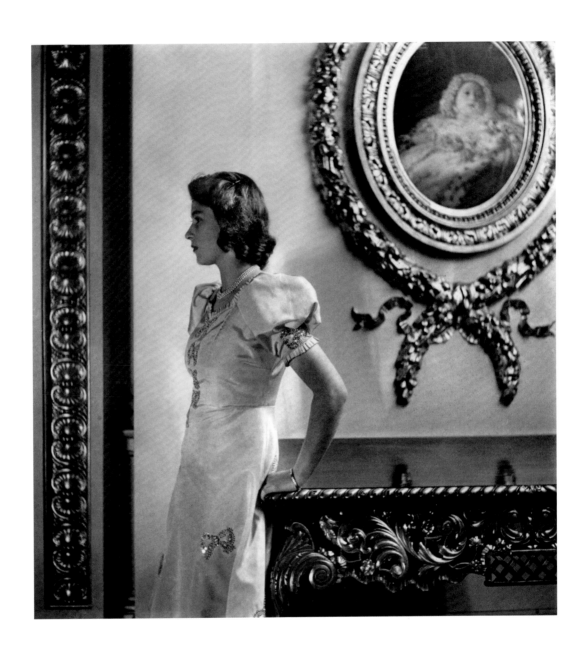

3

Princess Elizabeth in the Bow Room at Buckingham Palace, with a portrait of the Belgian
Prince Leopold by Franz Xaver Winterhalter framed above her, October 1942
Gelatin silver print, 20.2 × 19.3 cm
V&A: PH.289–1987

68

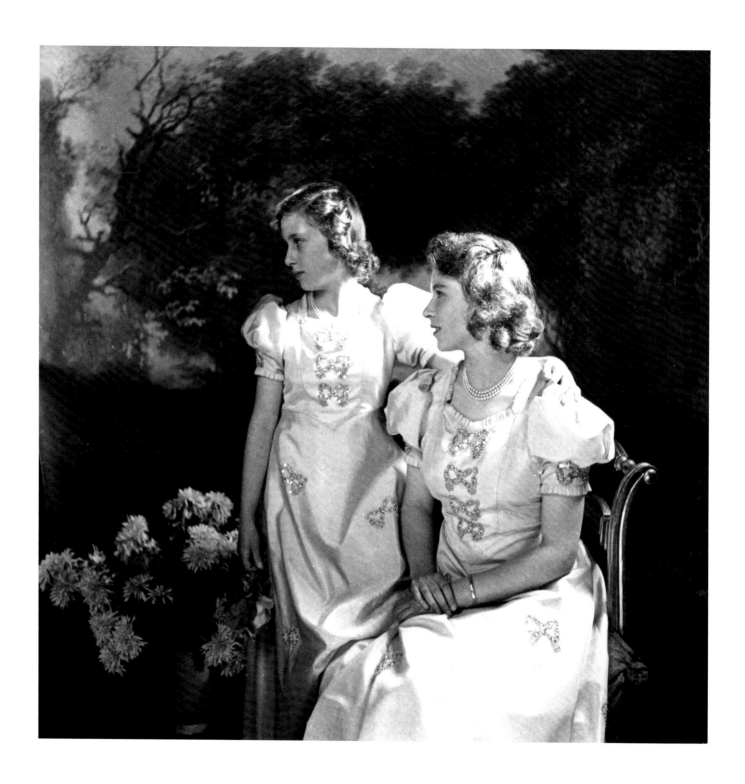

4
Princess Elizabeth and Princess Margaret, October 1942
Gelatin silver print, 18.5 × 18.7 cm
V&A: PH.619–1987

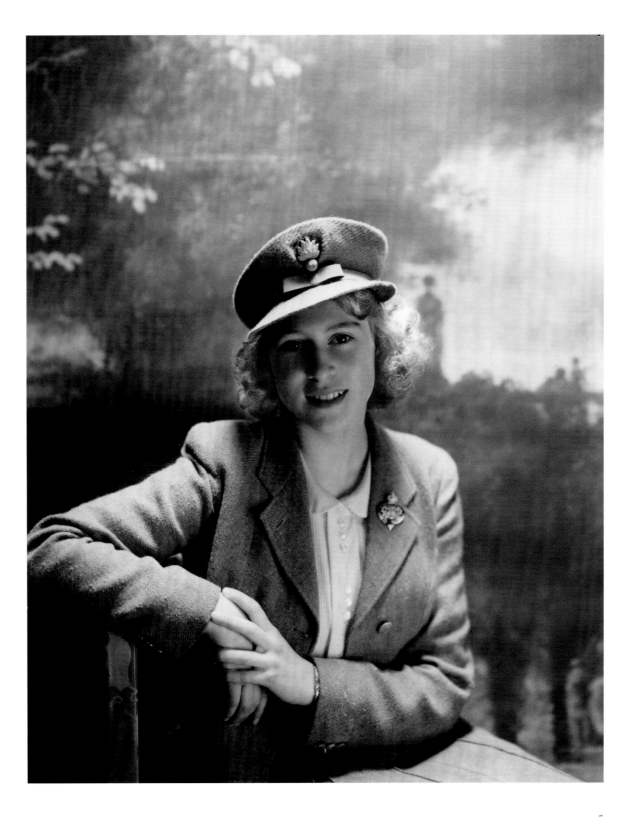

5

Princess Elizabeth, Colonel-in-Chief of the Grenadier Guards, October 1942
Gelatin silver print, 24 × 19.1 cm
V&A: PH.220–1987

6

The Royal Family, October 1942

Gelatin silver contact prints mounted on card, 26.2 × 26.7 cm

V&A: PH.499-A-Q-1987

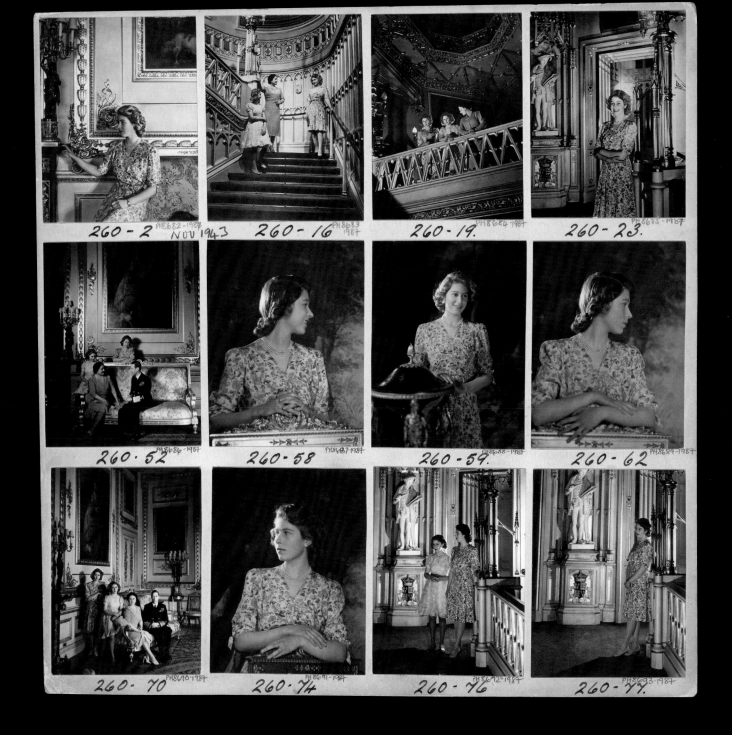

The Royal Family, Windsor Castle, November 1943
Gelatin silver contact prints mounted on card, 25 × 25 cm
V&A: PH.8682–8693–1987

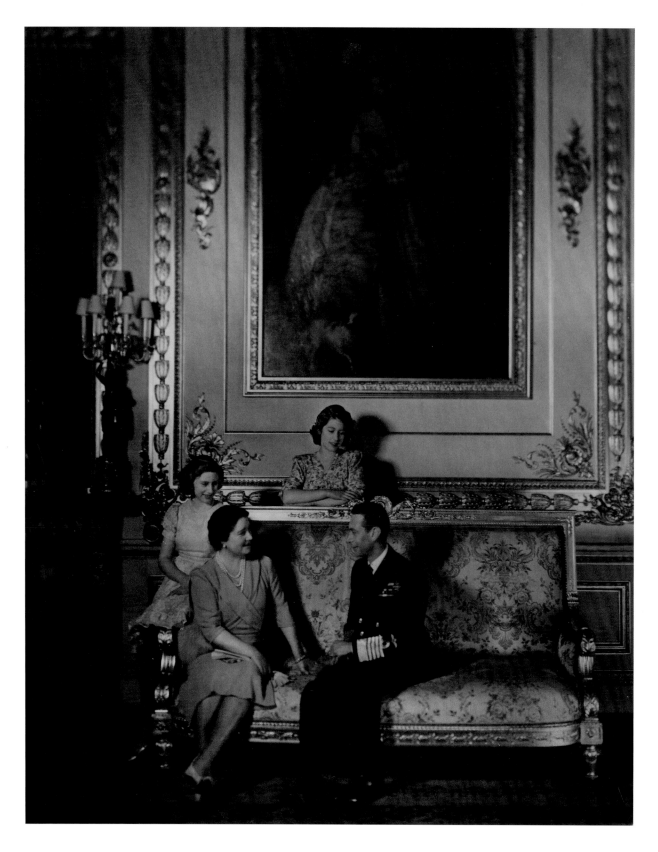

8
The Royal Family, with a portrait of Queen Charlotte (1871) by Thomas Gainsborough
hanging on the wall of the State Apartments at Windsor Castle, November 1943
Gelatin silver print, 24.4 × 19.3 cm
V&A: PH.1353–1987

'Princess Elizabeth's easy
charm, like her mother's,
does not carry across in her
photographs, and each time
one sees her one is delighted
to find how much more serene,
magnetic, and at the same
time meltingly sympathetic she
is than one had imagined …
One misses, even in colour
photographs, the effect of the
dazzlingly fresh complexion,
the clear regard from the
glass-blue eyes, and the gentle,
all-pervading sweetness of
her smile.'[1]

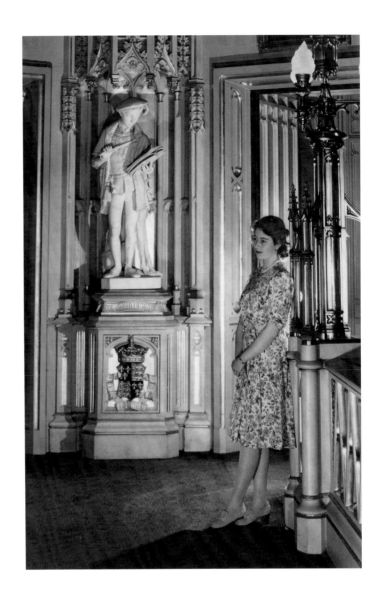

9
Princess Elizabeth, Windsor Castle, November 1943
Gelatin silver print, 24.4 × 16 cm
V&A: PH.245–1987

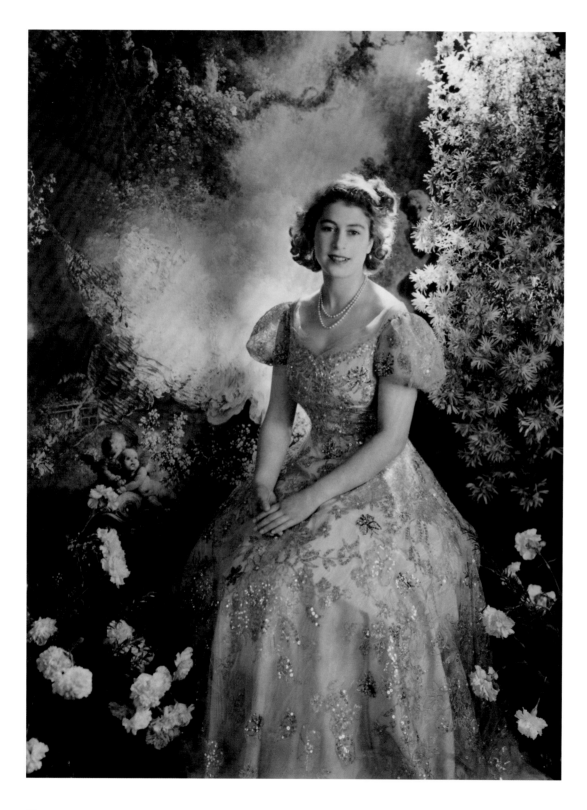

10
Princess Elizabeth, March 1945
Gelatin silver print, 24.1 × 17.8 cm
V&A: E.1561–2010

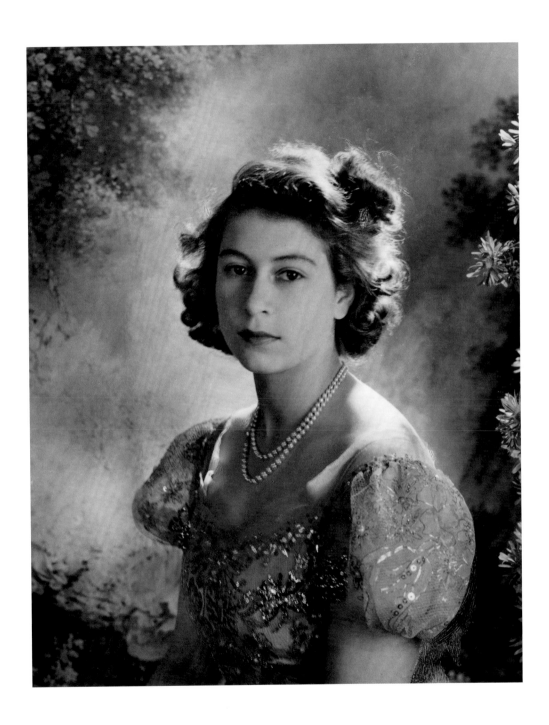

11
Princess Elizabeth, March 1945
Gelatin silver print, 25.5 × 20.3 cm
V&A: PH.4118–1987

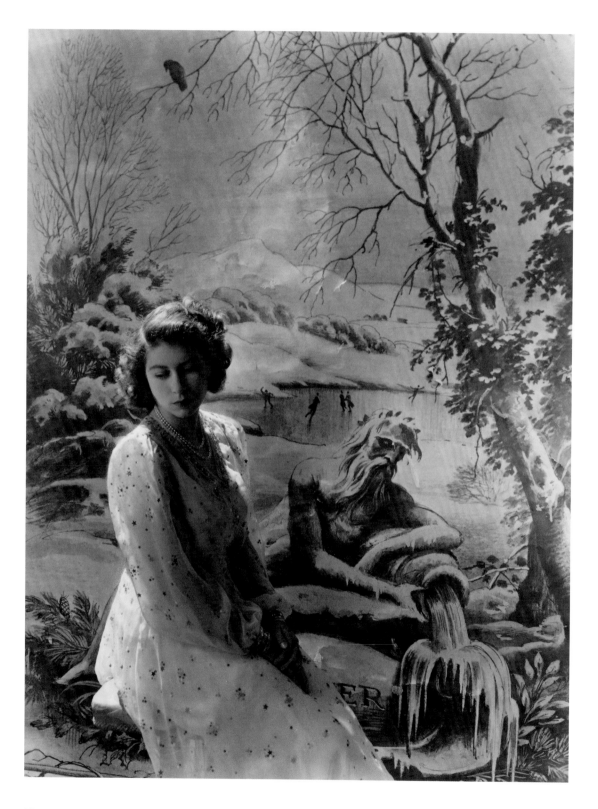

12
Princess Elizabeth, March 1945
Gelatin silver print, 24.1 × 18.4 cm
V&A: PH.420–1987

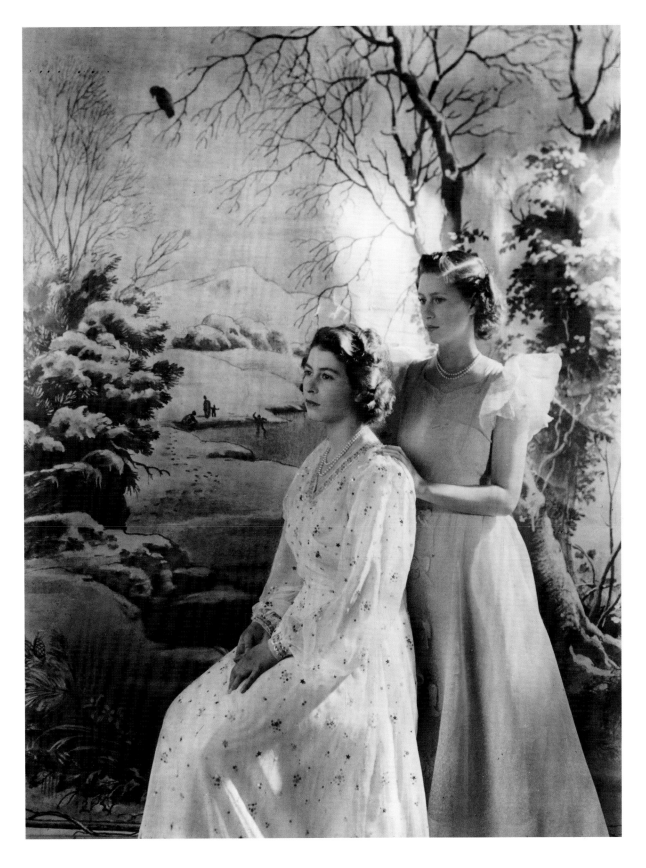

Princess Elizabeth and Princess Margaret, March 1945
Gelatin silver print, 24.4 × 18.6 cm
V&A: PH.6745–1987

14
Princess Elizabeth and Princess Margaret, March 1945
Gelatin silver contact prints mounted on card, 34.3 × 32.5 cm
V&A: PH.595A–V–1987

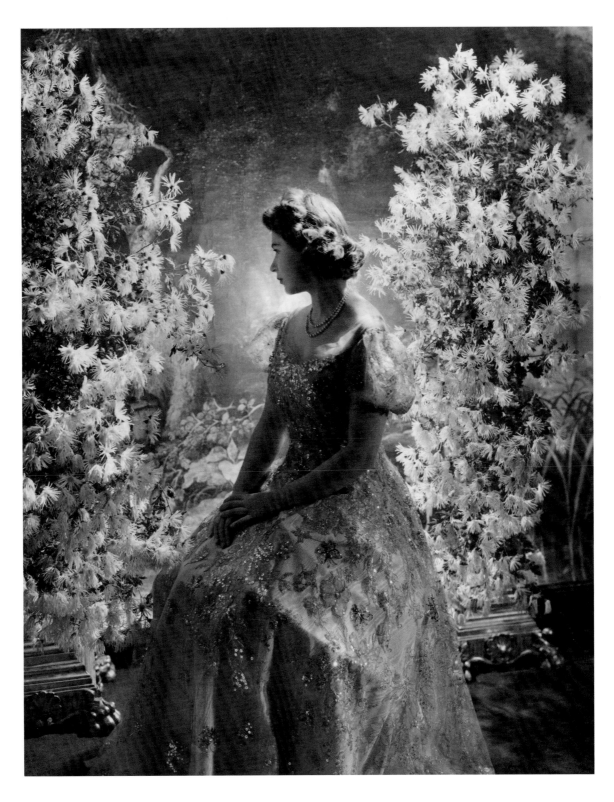

15
Princess Elizabeth, March 1945
Gelatin silver print, 24.2 × 19.3 cm
V&A: PH.1767–1987

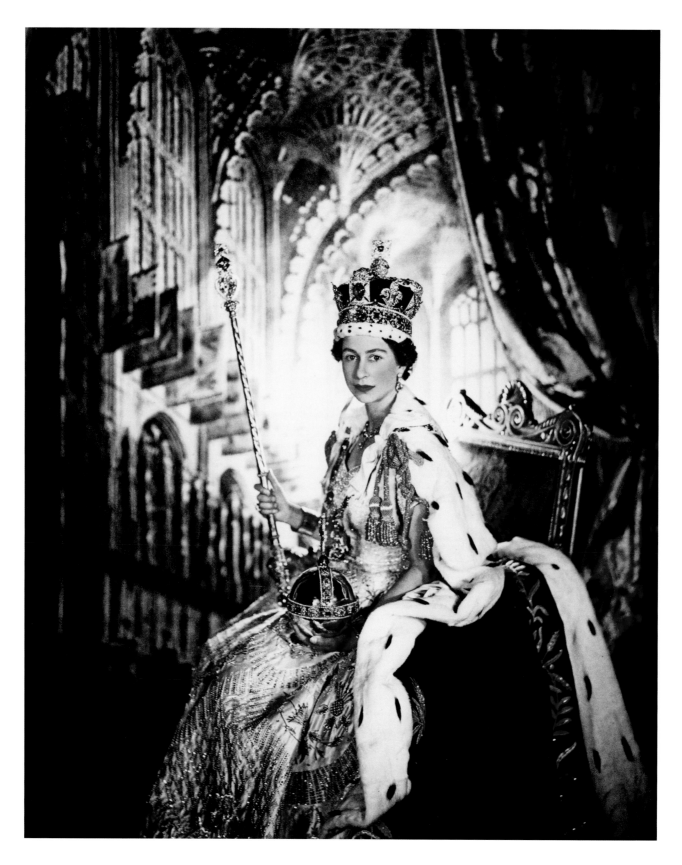

16
Queen Elizabeth II, 2 June 1953
C-type colour print, 52 × 42 cm
V&A: PH.311–1987

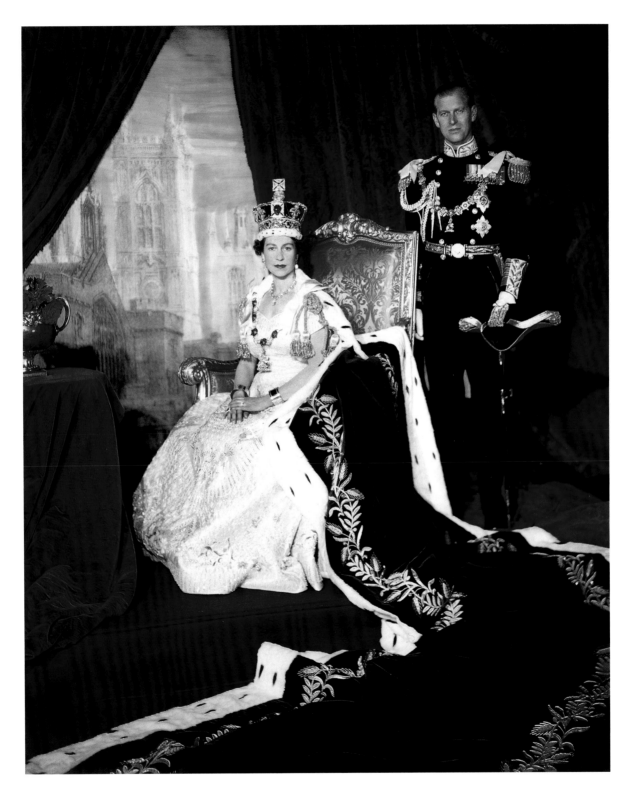

17
Queen Elizabeth II and Prince Philip, Duke of Edinburgh, 2 June 1953
C-type colour print, 52 × 42 cm
V&A: PH.305–1987

18
Prince Philip, Duke of Edinburgh, 2 June 1953
Gelatin silver print, 25.8 × 18.2 cm
V&A: PH.600–1987

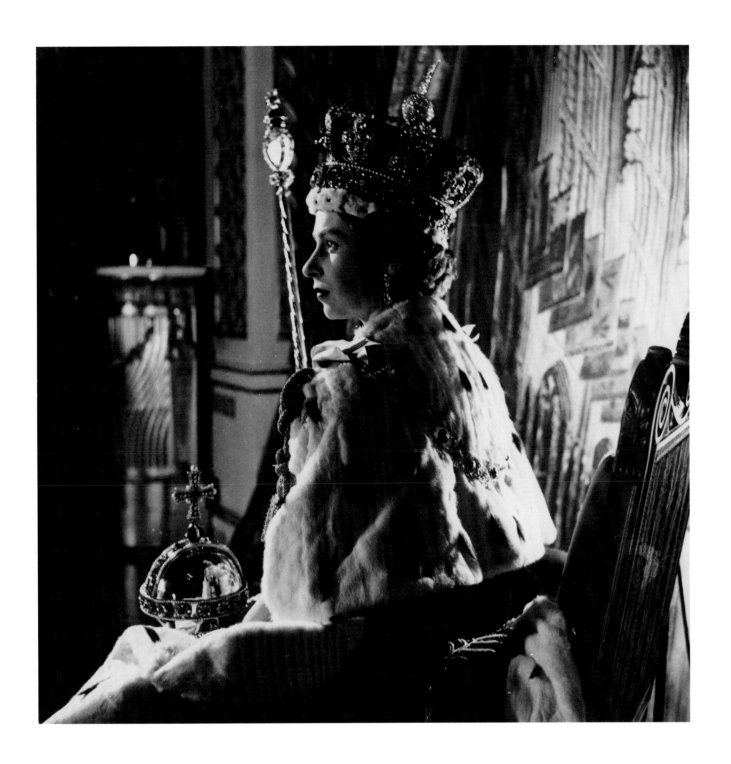

19
Queen Elizabeth II, 2 June 1953
Gelatin silver print, 23.9 × 23.8 cm
V&A: PH.1540–1987

20
Queen Elizabeth II and Prince Philip, Duke of Edinburgh, 2 June 1953
Gelatin silver contact prints mounted on card, 29.8 × 35.4 cm
V&A: PH.592A-L-1987

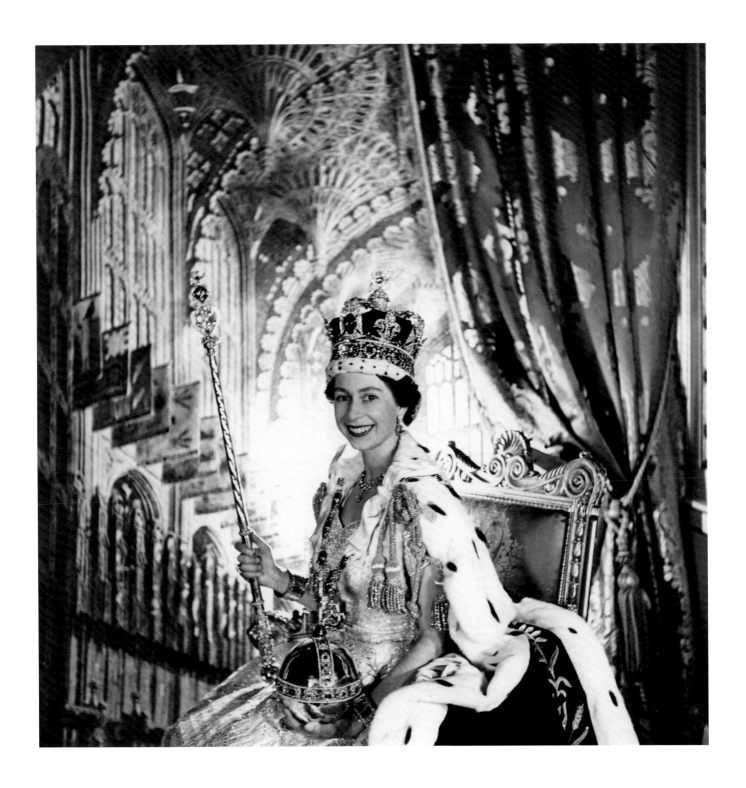

21
Queen Elizabeth II, 2 June 1953
Gelatin silver print, 23.7 × 23.6 cm
V&A: PH.231–1987

'All at once, and because of her, I was enjoying my work. Prince Charles and Princess Anne were buzzing about in the wildest excitement and would not keep still for a moment. The Queen Mother anchored them in her arms, put her head down to kiss Prince Charles's hair, and made a terrific picture.'[2]

Queen Elizabeth the Queen Mother, Prince Charles and Princess Anne, 2 June 1953
Gelatin silver print, 20.1 × 17.7 cm
V&A: E.1362–2010

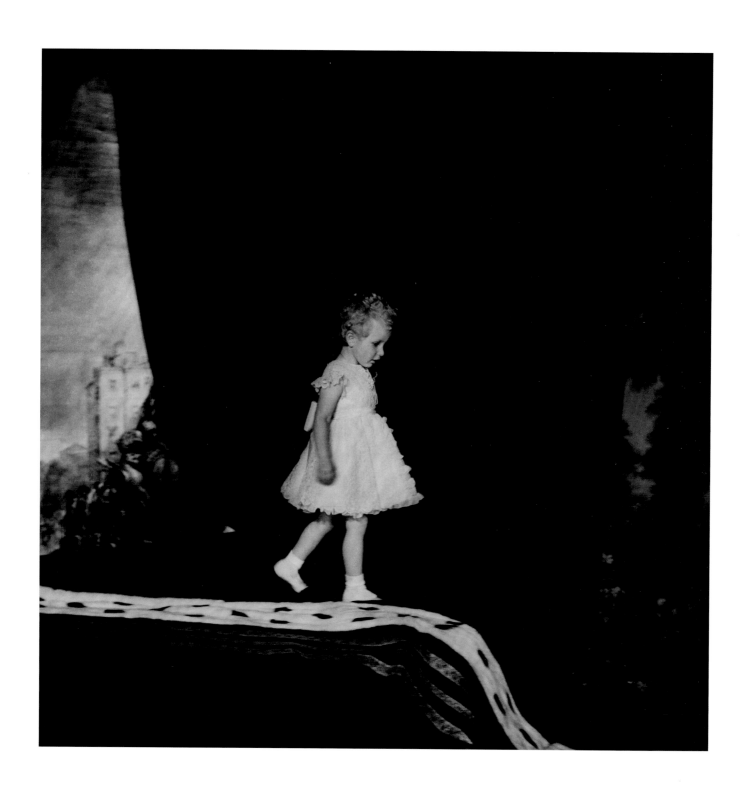

23
Princess Anne, 2 June 1953
Gelatin silver print, 24 × 24 cm
V&A: PH.324–1987

24
Queen Elizabeth the Queen Mother
and Prince Charles, 2 June 1953
Gelatin silver print, 19.8 × 19.1 cm
V&A: PH.559–1987

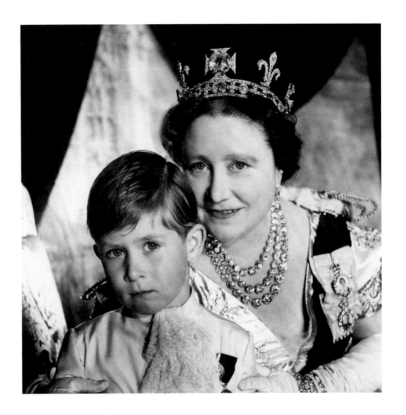

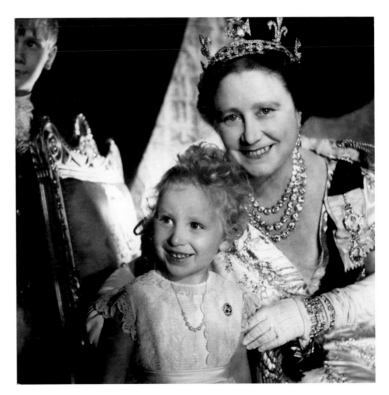

25
Queen Elizabeth the Queen Mother
and Princess Anne, 2 June 1953
Gelatin silver print, 18.9 × 19.2 cm
V&A: PH.1099–1987

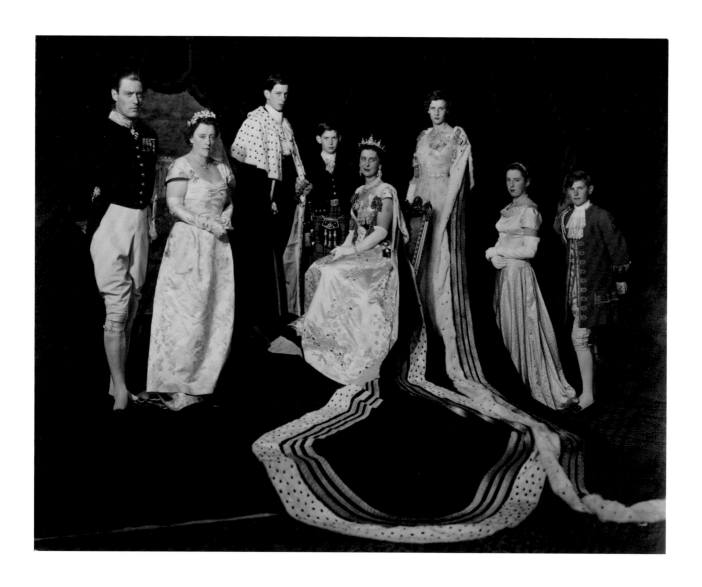

26
The Duke of Kent, Prince Michael, the Duchess of Kent and Princess Alexandra,
flanked by two ladies-in-waiting and two pages, 2 June 1953
Gelatin silver print, 20.1 × 25.5 cm
V&A: PH.1518–1987

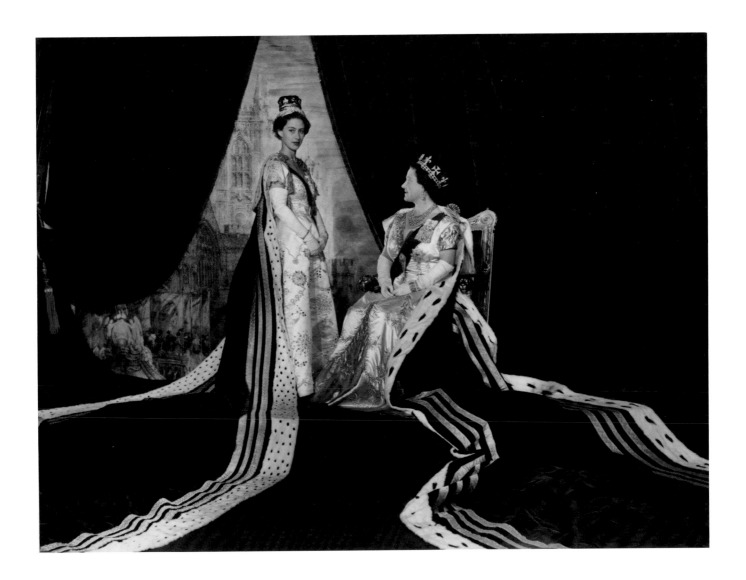

27
Princess Margaret and Queen Elizabeth the Queen Mother, 2 June 1953
Gelatin silver print, 18.3 × 25 cm
V&A: PH.258–1987

'We were all exhausted – the Queen most of all I should imagine. We had all been up since 5am and it was then about 4pm. Cecil Beaton was most particular about placing the six of us Maids of Honour around the Queen in the order we stood in the Abbey – the smallest ones in the front nearest the Queen. She seemed very tiny and fragile but rose to the occasion magnificently.'[3]

THE LADY RAYNE

28
Queen Elizabeth II with her Maids of Honour, 2 June 1953
Gelatin silver prints, 28.5 × 11.1 cm and 8.5 × 8.1 cm
V&A: PH.1499A-C-1987 and PH.1494-1987

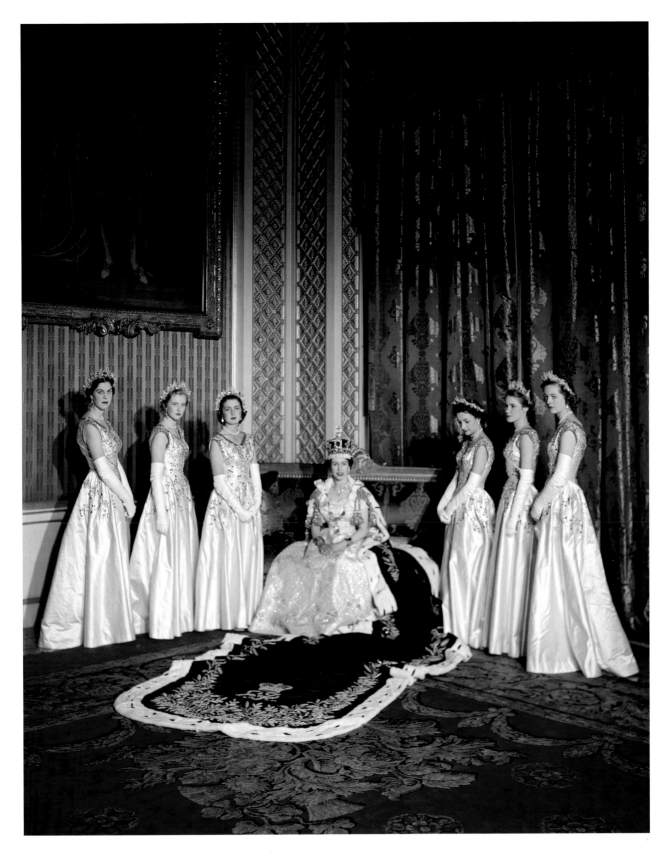

Queen Elizabeth II with her Maids of Honour, 2 June 1953
Colour transparency
V&A: E.1565–2010

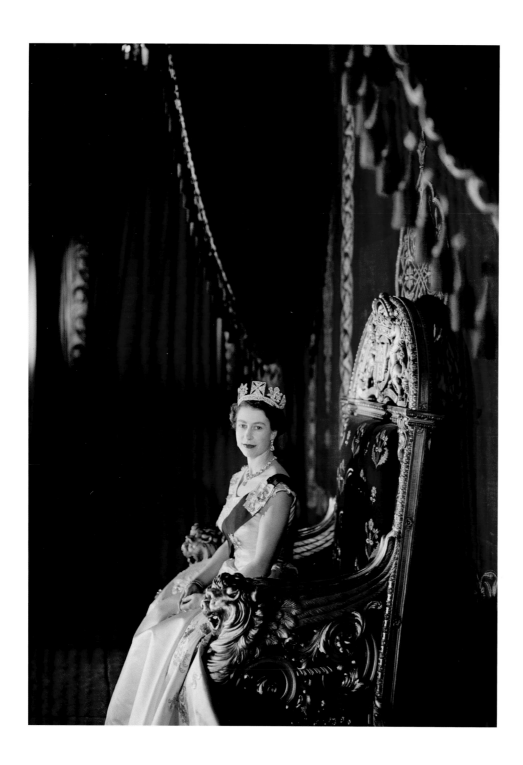

30
Queen Elizabeth II, November 1955
Colour transparency
V&A: E.1366–2010

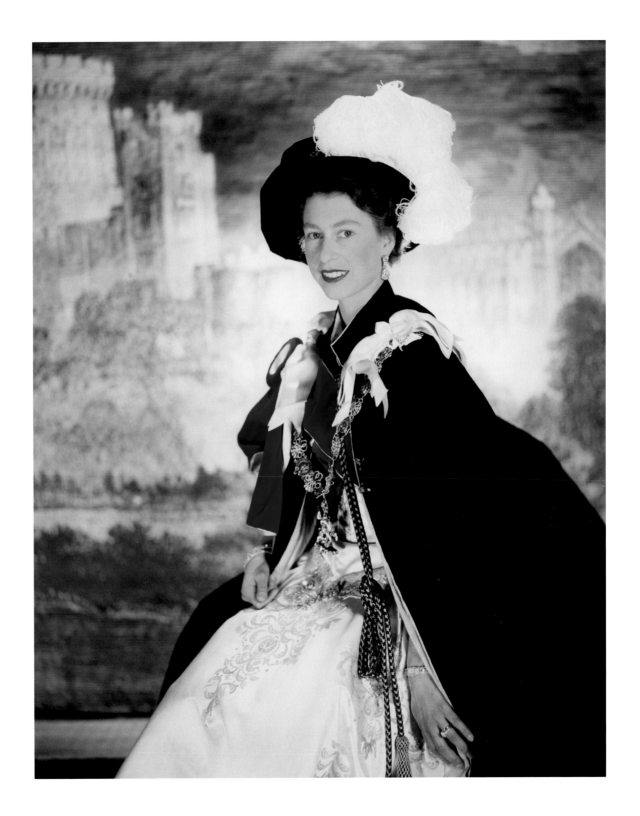

31
Queen Elizabeth II, November 1955
C-type colour print, 25.1 × 40.9 cm
V&A: PH.317–1987

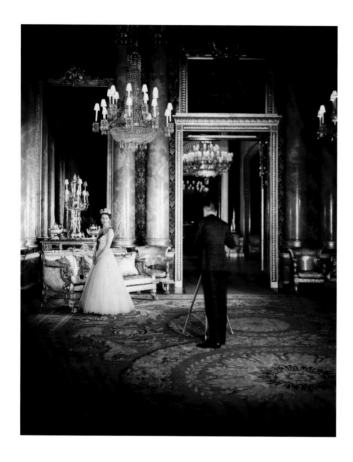

32
Unknown photographer, Queen Elizabeth II
being photographed by Cecil Beaton, November 1955
C-type colour print, 25.5 × 20.4 cm
V&A: E.1365–2010

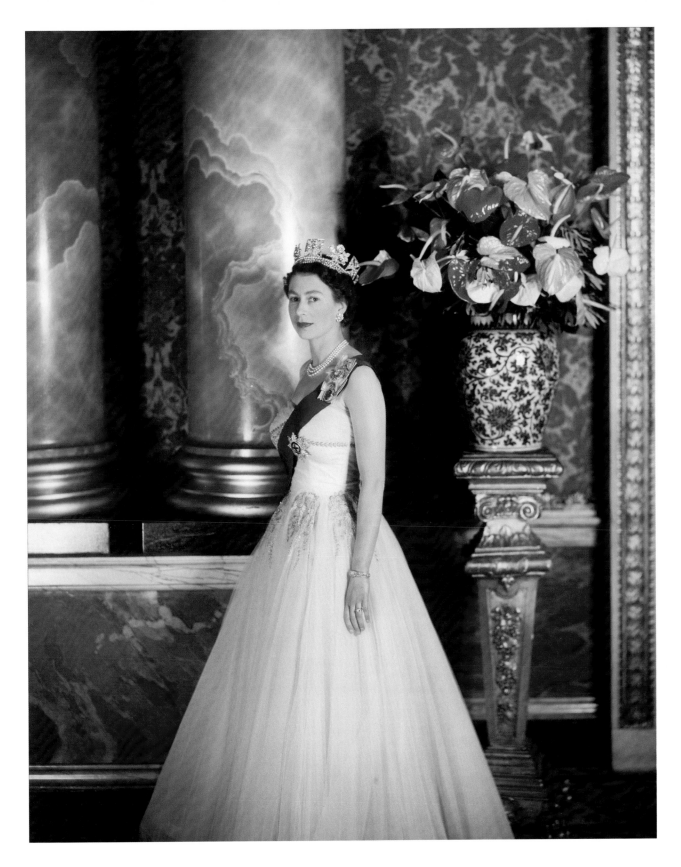

55

Queen Elizabeth II, November 1955
C-type colour print, 50.6 × 39.9 cm
V&A: PH.504–1987

'The Queen was enormously appealing to me.
Her dress was quite wonderfully romantic – with a skirt
of stiff folds – and everything of a kingfisher brilliance.
She seemed calm and sweetly sad.'[4]

Queen Elizabeth II, on Princess Margaret's wedding day, 6 May 1960
C-type colour print, 52.2 × 42.3 cm
V&A: PH.310–1987

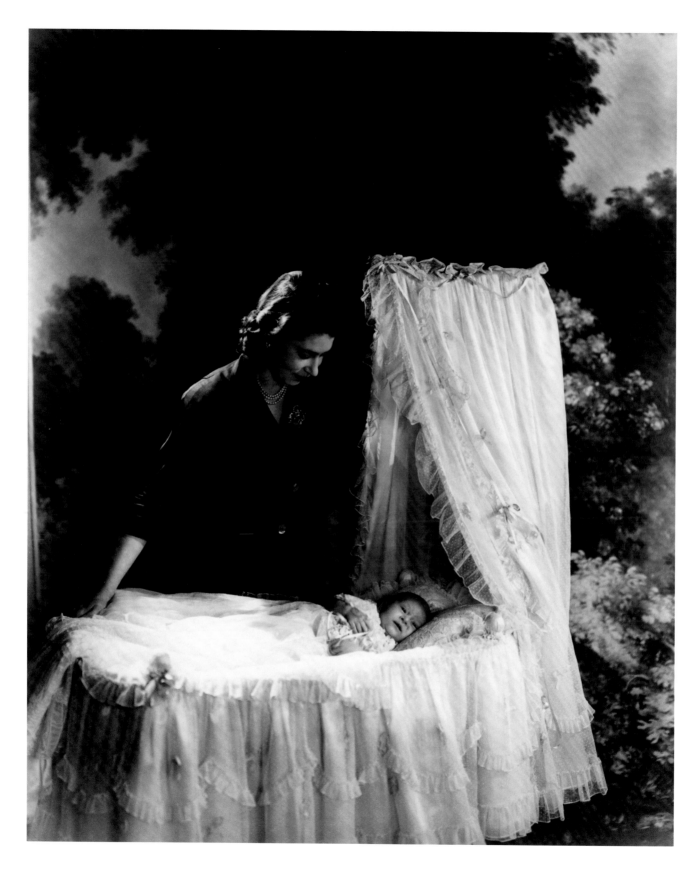

35
Princess Elizabeth and Prince Charles, December 1948
Gelatin silver print, 29.1 × 24 cm
V&A: PH.1461–1987

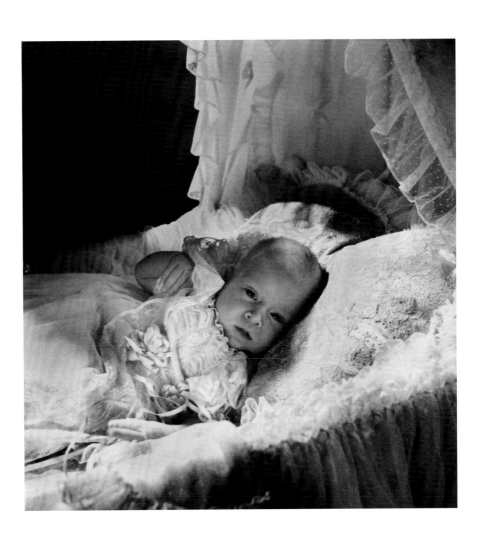

Prince Charles, December 1948
Gelatin silver print, 20.2 × 19.3 cm
V&A: PH.1457–1987

'*I photographed mother and son together in numberless different poses and, when the child had a bout of restlessness, Princess Elizabeth posed alone. I took many charming pictures of her in colour against the grisaille background of a landscape by Patinir, wearing a slate-blue dress, the only colour in the picture being provided by her pink cheeks and lips.*'[5]

37
Princess Elizabeth, December 1948
Colour transparency
V&A: E.1368–2010

38
Princess Elizabeth, December 1948
Colour transparency
V&A: E.1567–2010

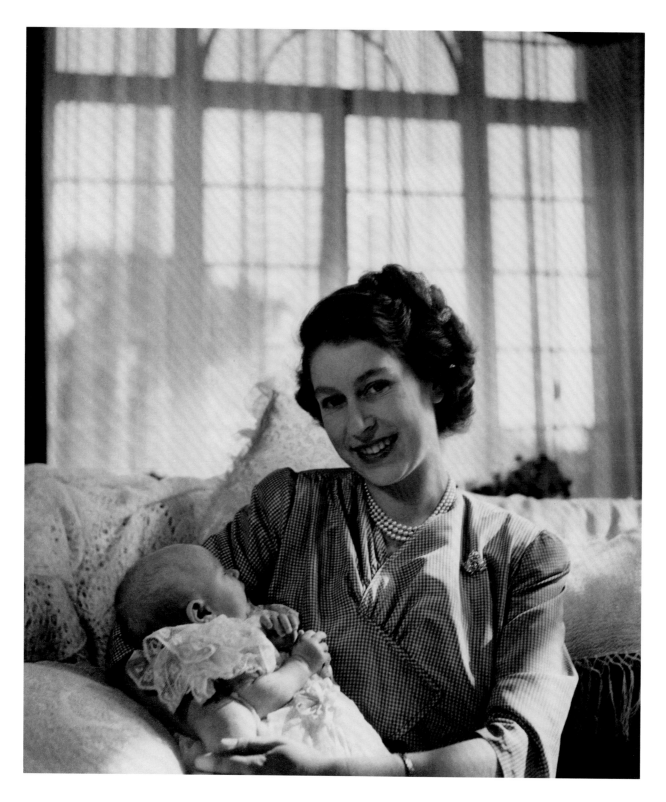

39
Princess Elizabeth and Princess Anne, Clarence House, September 1950
Gelatin silver print, 25 × 21.5 cm
V&A: E.1369–2010

'Prince Charles was at the stage when he was interested in everything ... at one moment – it reminded me of the great moment in The Sleeping Beauty ballet – he kissed the baby on her cheek, and I was able to get the best picture of the afternoon.'[6]

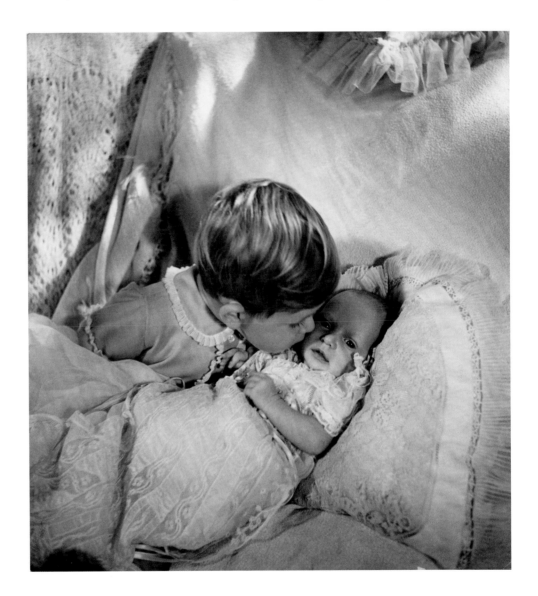

40
Prince Charles and Princess Anne, Clarence House, September 1950
Gelatin silver print, 25.4 × 23.6 cm
V&A: PH.642–1987

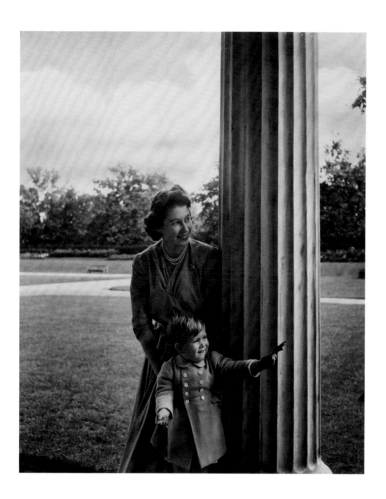

41
Princess Elizabeth and Prince Charles,
Clarence House, September 1950
Gelatin silver print, 25 × 20.3 cm
V&A: PH.319–1987

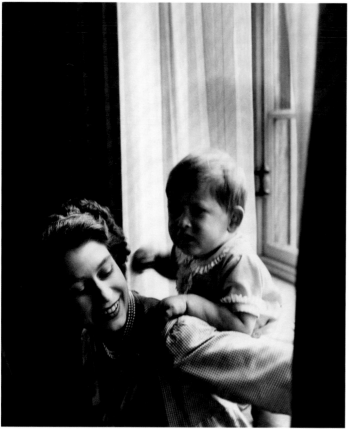

42
Princess Elizabeth and Prince Charles,
Clarence House, September 1950
Gelatin silver print, 36 × 31.4 cm
V&A: E.1626–1989

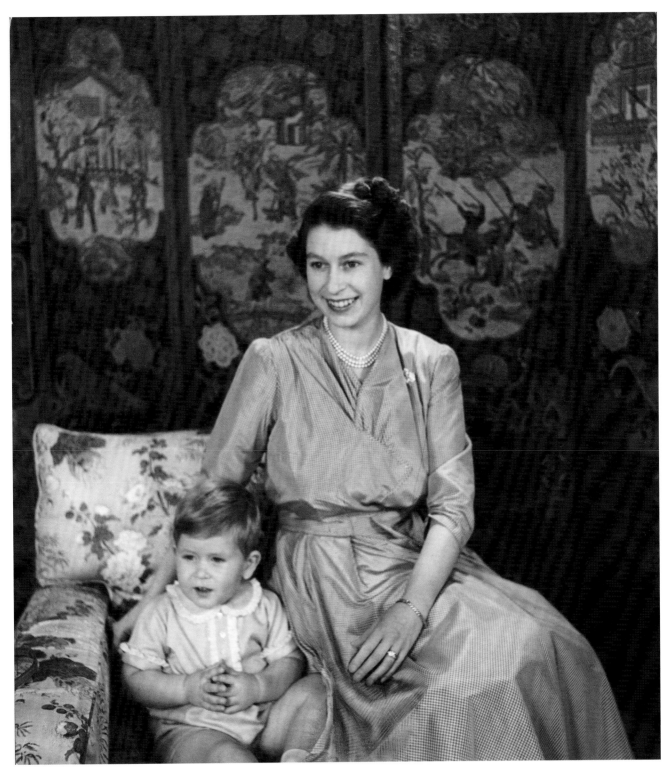

43
Princess Elizabeth and Prince Charles,
Clarence House, September 1950
Gelatin silver print, 29.9 × 26.7 cm
V&A: PH.1484–1987

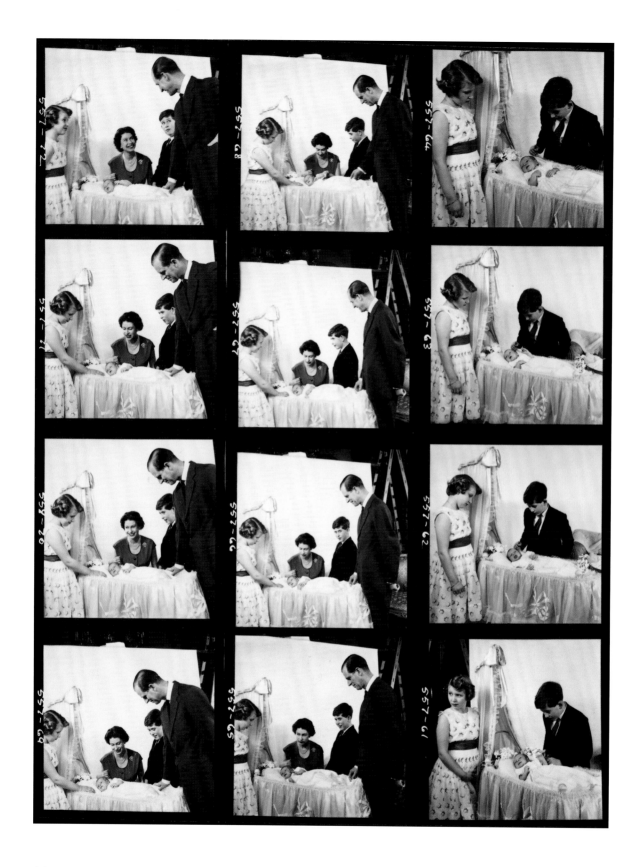

44
Queen Elizabeth II, Prince Philip, Duke of Edinburgh,
Prince Charles, Princess Anne, Prince Andrew, March 1960
Gelatin silver print, contact sheet, 24.8 × 19 cm
V&A: PH.1708–1987

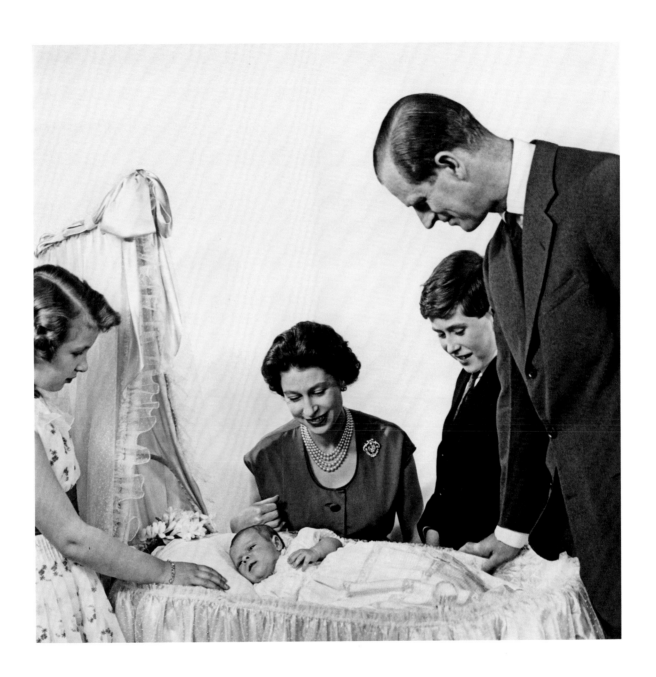

45
Queen Elizabeth II, Prince Philip, Duke of Edinburgh,
Prince Charles, Princess Anne, Prince Andrew, March 1960
Gelatin silver print, 23.8 × 24.4 cm
V&A: PH.229–1987

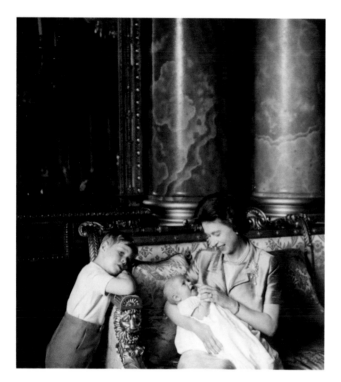

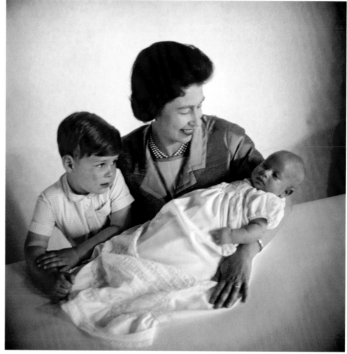

46
Queen Elizabeth II, Prince Andrew and Prince Edward, May 1964
Gelatin silver print, 12.9 × 11.8 cm
V&A: PH.9281–1987

47
Queen Elizabeth II, Prince Andrew and Prince Edward, May 1964
Colour transparency
V&A: PH.1737–1987

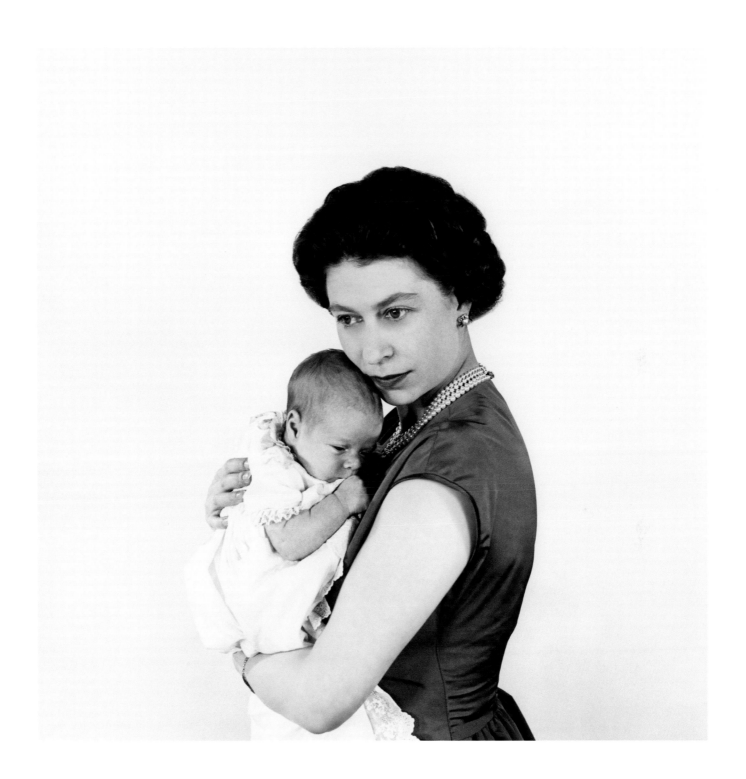

Queen Elizabeth II and Prince Andrew, March 1960
Gelatin silver print, 24 × 24 cm
V&A: PH.1806–1987

'The Queen's wide grin dominated the picture and other felicitous elements were provided by Andrew's blue wistful little boy's eyes – and the infant holding its own by being alert, curious and already a character.'[7]

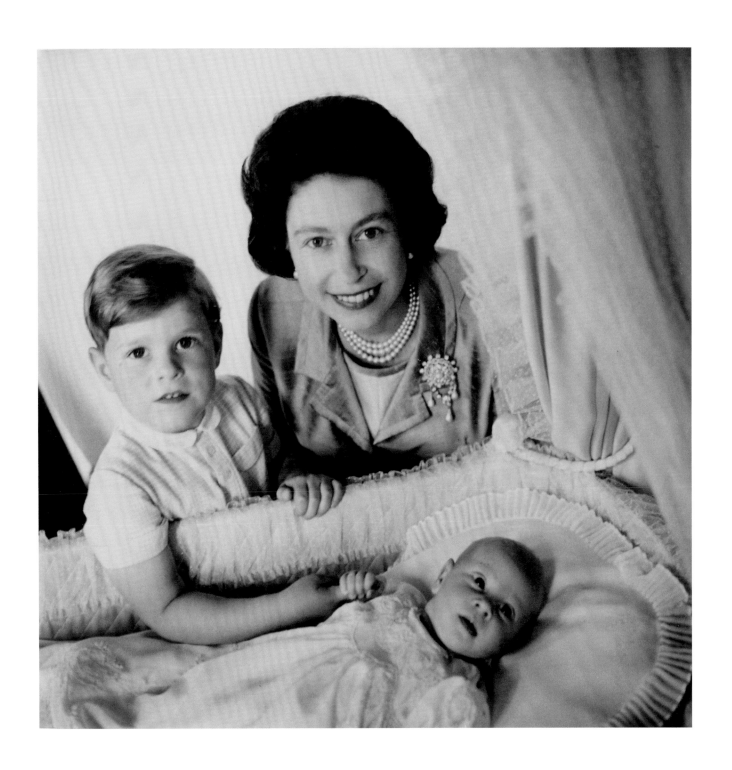

49
Queen Elizabeth II, Prince Andrew and Prince Edward, May 1964
Gelatin silver print, 24.4 × 24.4 cm
V&A: PH.256–1987

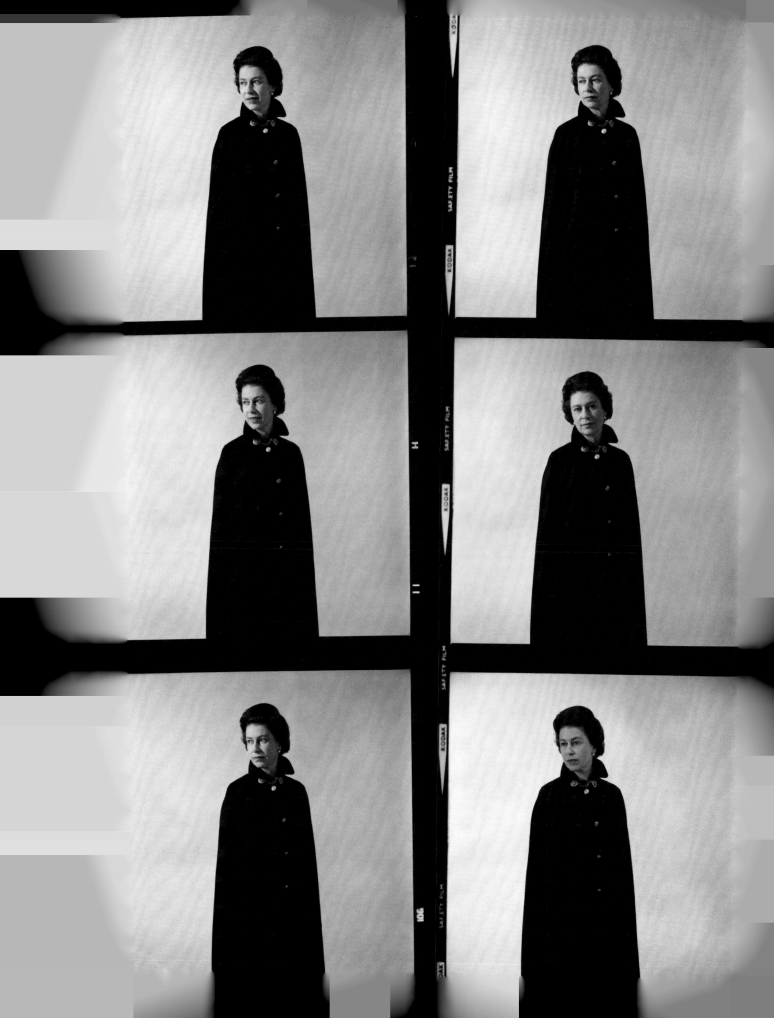

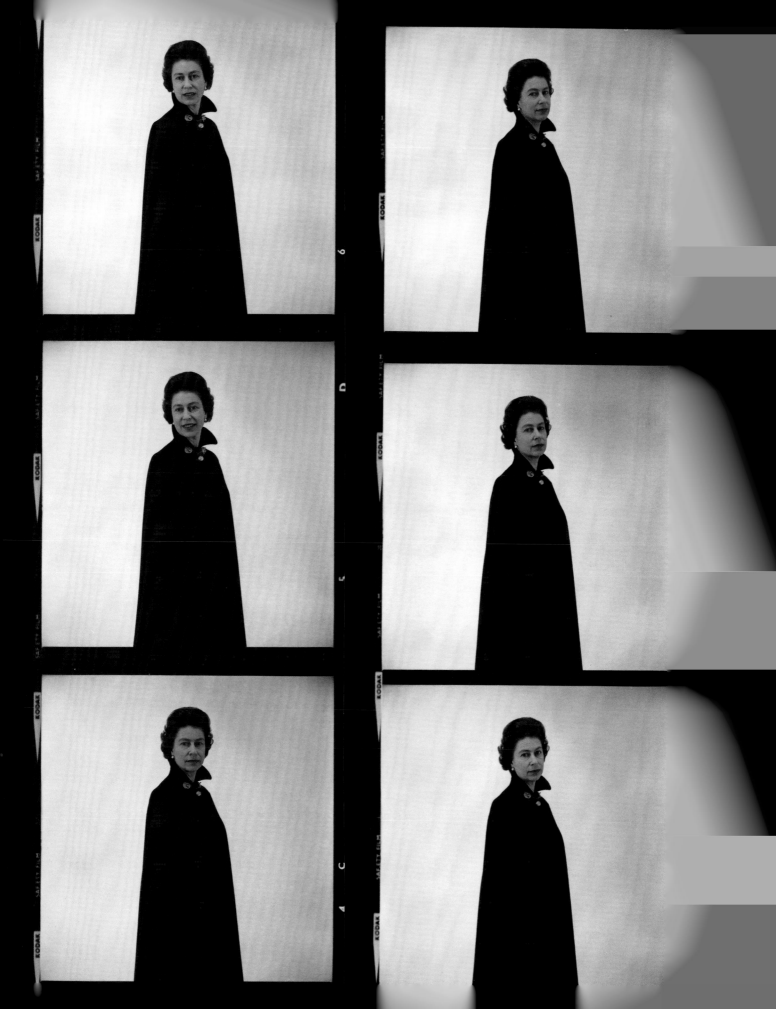

'Then suddenly she turned to the left and the head tilted,
and this was the clue to the whole sitting – the tilt. I kept
up a running conversation, trying to be funny, trying
to keep the mirth light ... By now I felt I had
started to get something and was busy duplicating
this one pose that I felt had provided
the afternoon's solution.'[8]

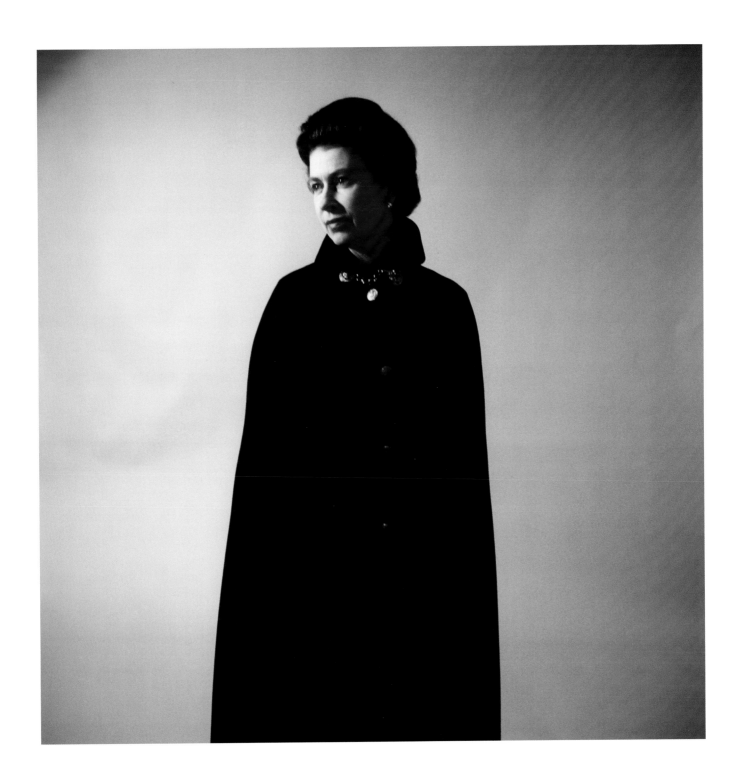

51
Queen Elizabeth II, September 1968
C-type colour print, 42.5 × 42.5 cm
V&A: PH.318–1987

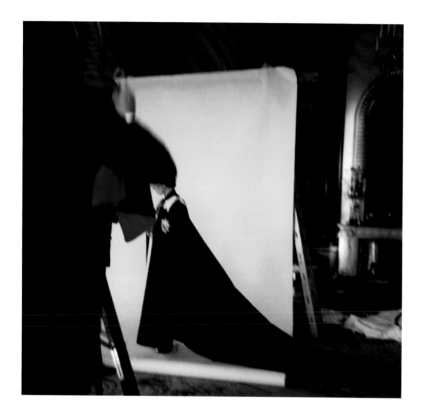

52
Queen Elizabeth II with one of Beaton's assistants
in the foreground, September 1968
Colour transparency
V&A: PH.635A–1987

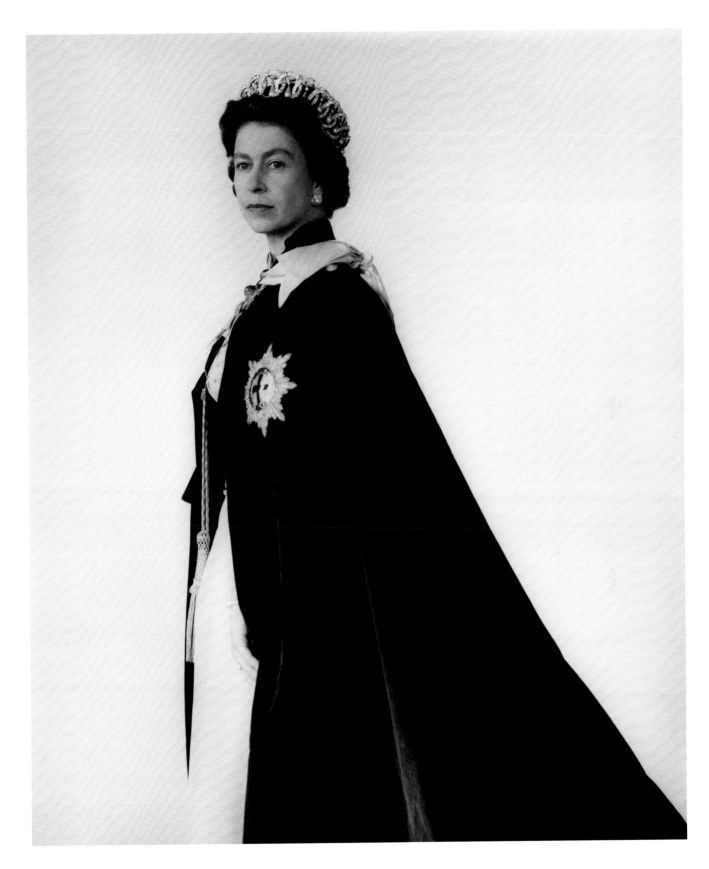

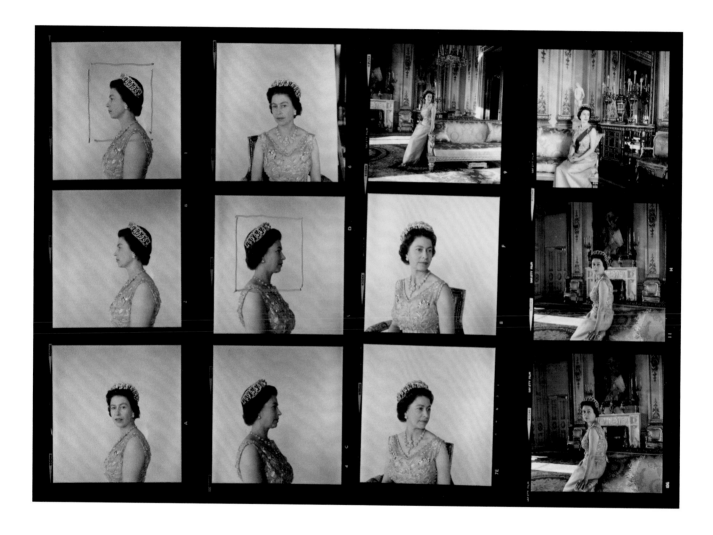

54
Queen Elizabeth II, September 1968
Gelatin silver print, marked-up contact sheet, 25.7 × 30.4 cm
V&A: PH.2013–1987

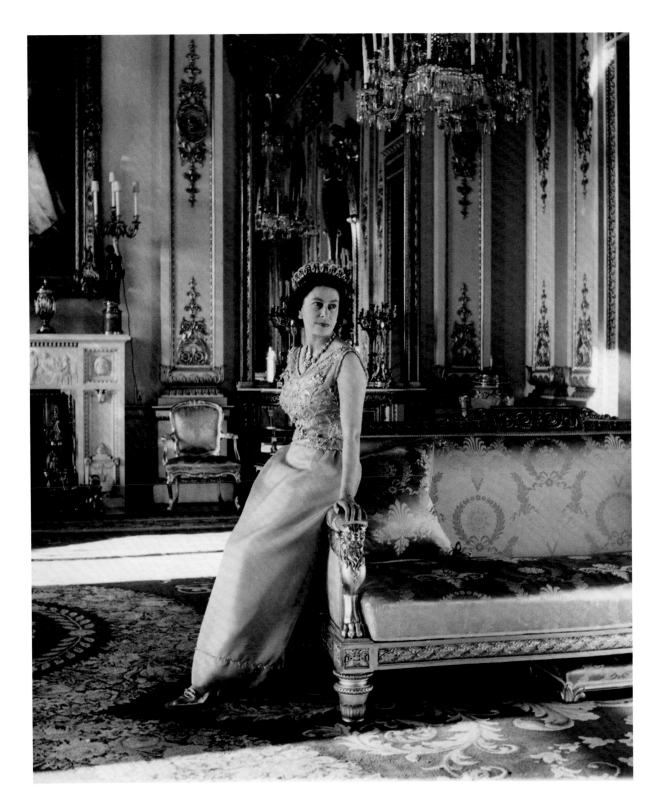

55
Queen Elizabeth II, September 1968
Gelatin silver print, 30.3 × 25.4 cm
V&A: PH.1925–1987

'The sun was now shining for the rest of the afternoon and I bade the many assistants bring in our background from the dark cavern and rely on God's glorious daylight. Everywhere were sparkling possibilities. The Queen reappeared in a vivid turquoise-blue dress, the Garter mantle and Queen Mary's pearl and diamond looped tiara.'[9]

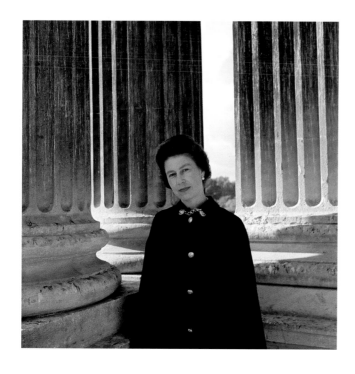

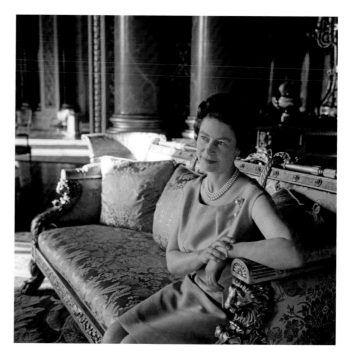

56
Queen Elizabeth II, September 1968
Colour transparency
V&A: PH.8816–1987

57
Queen Elizabeth II, September 1968
Colour transparency
V&A: PH.8809–1987

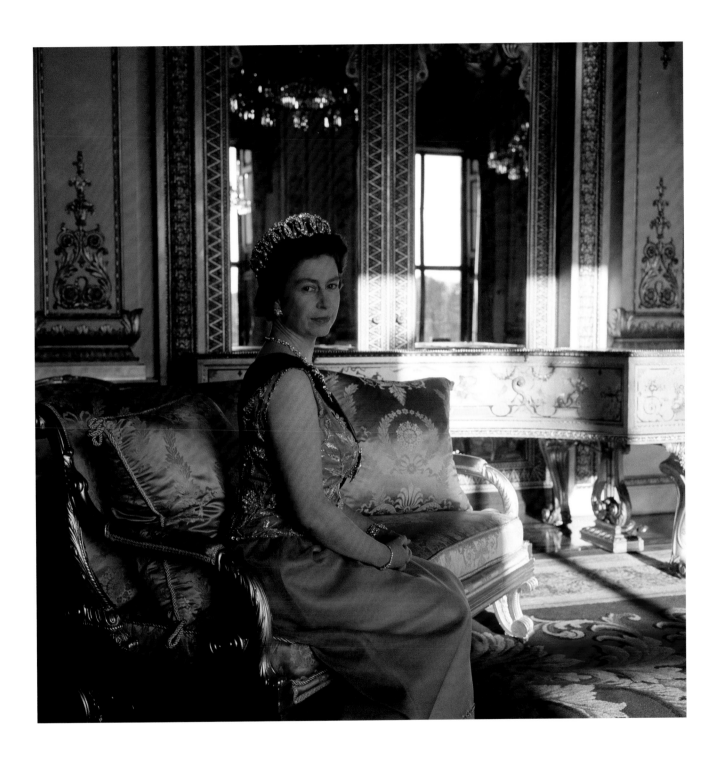

58
Queen Elizabeth II, September 1968
Colour transparency
V&A: E.1372–2010

Notes

Preface

1 Cecil Beaton diary entry, July 1939, in Cecil Beaton,
 The Wandering Years, Diaries: 1922–1939 (London, 1961),
 p.372

2 Mark Haworth-Booth, 'Cecil Beaton: Photographer as
 Courtier', in Kathleen Collins (ed.), *Shadow and Substance:
 Essays on the History of Photography, In Honor of Heinz
 K. Henisch* (Michigan, 1990), p.269

The Queen and Cecil Beaton

1 Cecil Beaton, *The Wandering Years, Diaries: 1922–1939*
 (London, 1961), p.29

2 Cecil Beaton, *Photobiography* (London, 1951), p.21

3 Cecil Beaton, *The Years Between, Diaries: 1939–1944*
 (London, 1965), p.28

4 Based on average earnings, a half-crown is a little over
 £20 in today's money.

5 *Photobiography*, p.33

6 Unknown newspaper, December 1925, Cecil Beaton press
 cuttings AAD/1986/13/1

7 *Photobiography*, pp.42–3

8 *The Wandering Years, Diaries: 1922–1939*, p.47

9 *Photobiography*, p.22

10 Peter Conrad, 'Beaton in Brilliantia', in Terence Pepper
 (ed.), *Beaton Portraits* (London, 2004), p.59

11 *Photobiography*, pp.42–3

12 *The Wandering Years, Diaries: 1922–1939*, p.102

13 *Photobiography*, p.53

14 Letter from Alexander Liberman to Cecil Beaton,
 27 October 1944, St John's College Library,
 Cambridge University

15 *The Sunday Herald*, 27 November 1927, Cecil Beaton
 press cuttings AAD/1986/13/2. The critic describes Beaton
 as 'not yet twenty', but he was actually 23 years old.

16 *The Wandering Years, Diaries: 1922–1939*, p.375

17 In 1940, Beaton and his mother moved to 8 Pelham Place,
 a Regency house a stone's throw from the Victoria and
 Albert Museum.

18 Robin Muir, *The World's Most Photographed*
 (London, 2005), p.12

19 For more information on early royal photographs,
 see Frances Dimond and Roger Taylor, *Crown & Camera:
 The Royal Family and Photography 1842–1910* (London,
 1987) and Colin Ford (ed.), *Happy and Glorious:
 Six Reigns of Royal Photography* (London, 1977).

20 Roy Strong, *Cecil Beaton: The Royal Portraits*
 (London, 1988), p.36

21 Strong, p.20

22 *Daily Sketch*, 4 December 1939, Cecil Beaton press cuttings
 AAD/1986/13/23

23 Alexis Schwarzenbach, 'Royal Photographs: Emotions
 for the People', *Contemporary European History*
 (Cambridge, August 2004), vol.13, no.3, p.258. Other
 portraits of the Queen from this sitting with Beaton
 were similarly printed with frames in the *Daily Sketch* on
 5 March 1940, Cecil Beaton press cuttings AAD/1986/13/23.

24 *Daily Mirror*, 5 December 1939, p.3

25 *Tatler*, 6 March 1940, Cecil Beaton press cuttings
 AAD/1986/13/23

26 *Queen*, 13 March 1940, Cecil Beaton press cuttings
 AAD/1986/13/23

27 *The Years Between, Diaries: 1939–1944*, p.209

28 Strong, p.29

29 The Grenadier Guards Christmas card was illustrated in
 The Daily Express, 21 December 1942, Cecil Beaton press
 cuttings AAD/1986/13/23. The same image also appeared
 on the cover of *Life* magazine on 15 February 1943.

30 *Daily Sketch*, 4 January 1943, Cecil Beaton press cuttings
 AAD/1986/13/27

31 *The Years Between, Diaries: 1939–1944*, p.38

32 Cecil Beaton, 'What the Queen said to the Photographer',
 Sunday Express, 1 July 1951, Cecil Beaton press cuttings
 AAD/1986/13/33

33 Eileen Hose, 'The Royal Portraits' in the guide to the V&A
 exhibition *The Royal Photographs of Sir Cecil Beaton*,
 foreword by Sir George Bellew (1987), p.5

34 Strong, p.104

35 Cecil Beaton, *The Strenuous Years, Diaries: 1948–1955*
 (London, 1973), p.144

36 Churchill's speech on Coronation day, quoted in
 The Coronation Album (London, 1953) p.71

37 *The Strenuous Years, Diaries: 1948–1955*, p.136

38 *The Strenuous Years, Diaries: 1948–1955*, pp.142–3

39 Strong, p.35

40 *The Strenuous Years, Diaries: 1948–1955*, p.146

41 Ibid.

42 The backdrop depicting a view of Westminster Abbey from
 the river was based on *View of the Debarkation on Lord
 Mayor's Day* (1844), an engraving by Edward Goodall after
 the painting by David Roberts (1850).

43 *The Strenuous Years, Diaries: 1948–1955*, p.146

44 Cecil Beaton, *Royal Portraits*, introduction by
 Peter Quennell (London and New York, 1963)

45 Undated letter to Prince Philip from Martin Charteris,
 Royal Photographic Collection, Windsor

46 Elizabeth II's Maids of Honour: Lady Mary Baillie-
 Hamilton, now Lady Mary Russell; Lady Vane-Tempest-
 Stewart, now The Lady Rayne; Lady Jane Heathcote-
 Drummond-Willoughby, now The Baroness Willoughby de
 Eresby; Lady Anne Coke, now The Lady Glenconner; Lady
 Rosemary Spencer-Churchill, now Lady Rosemary Muir;
 Lady Moyra Hamilton, now Lady Moyra Campbell.

47 Author's interview with The Lady Rayne, September 2010

48 *The Strenuous Years, Diaries: 1948–1955*, p.150

49 *The Strenuous Years, Diaries: 1948–1955*, p.17

50 *Photobiography*, p.148

51 'The Radiant Mother: H.R.H. Princess Elizabeth with her baby son', *The Illustrated London News*, 8 January 1949, Cecil Beaton press cuttings AAD/1986/13/32

52 *Photobiography*, p.153

53 *The Sunday Graphic and Sunday News*, 17 September 1950, Cecil Beaton press cuttings AAD/1986/13/33

54 Letter from Winifred E. Wilson, Norwich, published in *The Sunday Graphic and Sunday News*, 24 September 1950, Cecil Beaton press cuttings AAD/1986/13/33

55 Letter from Queen Elizabeth II to Sister Rowe, quoted in http://www.timesonline.co.uk/tol/news/uk/article785978.ece

56 Beaton letters, St John's College Library, Cambridge University

57 Jennifer Scott, *The Royal Portrait: Image and Impact* (London, 2010), p.165

58 Strong, p.167

59 Hose, p.5

60 Author's interview with Geoffrey Sawyer, September 2010

61 Siriol Hugh-Jones, 'You Can Hold the Light Meter', *The Listener*, 31 October 1963, Cecil Beaton press cuttings AAD/1986/13/42

62 Beaton, *Royal Portraits*

63 Beaton letters, St John's College Library, Cambridge University

64 Hugo Vickers (ed.), *Beaton in the Sixties: More Unexpurgated Diaries* (London, 2004), p.303

65 Archive material from the Royal Photograph Collection, Windsor Castle, quoted in Jennifer Scott, p.171

66 Vickers, p.303

67 Vickers, p.304

68 Vickers, p.305

69 Vickers, p.306

70 Scott, p.165

71 Vickers, p.306

72 'Cloaked in Drama – The Queen by Beaton', *The Sun*, 1 November 1968, Cecil Beaton press cuttings AAD/1986/13/43

Plates

1 Cecil Beaton, 'What the Queen said to the Photographer', *Sunday Express*, 1 July 1951, Cecil Beaton press cuttings AAD/1986/13/33

2 Cecil Beaton, *The Strenuous Years, Diaries: 1948–1955* (London, 1973), p.146

3 Author's interview with The Lady Rayne, September 2010

4 Roy Strong, *Cecil Beaton: The Royal Portraits* (London, 1988), p.167

5 Cecil Beaton, *Photobiography* (London, 1951), p.210

6 *Photobiography*, p.153

7 Richard Buckle (ed.), *Self Portrait with Friends: The Selected Diaries of Cecil Beaton* (London, 1979), p.372

8 Hugo Vickers (ed.), *Beaton in the Sixties: More Unexpurgated Diaries* (London, 2004), p.305

9 Vickers, p.306

Select Bibliography

Cecil Beaton's Diaries

The Wandering Years, Diaries: 1922–1939 (London, 1961)
The Years Between, Diaries: 1939–44 (London, 1965)
The Happy Years, Diaries: 1944–1948 (London, 1972); also
 published in America as *Memoirs of the Forties* (New York,
 1972); and in France as *Les Années Heureuses* (Paris, 1972)
The Strenuous Years, Diaries: 1948–1955 (London, 1973)
The Restless Years, Diaries: 1955–1963 (London, 1976)
The Parting Years, Diaries: 1963–1974 (London, 1978)
*Self Portrait with Friends: The Selected Diaries of Cecil Beaton,
 1922–1974*, Richard Buckle (ed.) (London, 1979);
 also published in America (New York, 1979);
 and reprinted (London, 1991)
*The Unexpurgated Beaton: The Cecil Beaton Diaries as they
 were written*, introduction by Hugo Vickers
 (London, 2003)
Beaton in the Sixties: More Unexpurgated Diaries,
 introduction by Hugo Vickers (London, 2004)

Books by Cecil Beaton

The Book of Beauty (London, 1930)
Cecil Beaton's Scrapbook (London, 1937)
*My Royal Past: The Memoirs of Baroness von Bülop née Princess
 Theodora Louise Alexina Ludmilla Sophie von Eckermann-
 Waldstein, as told to Cecil Beaton* (London, 1939);
 reprinted (London, 1960)
*History Under Fire: 52 Photographs of Air Raid Damage to
 London Buildings, 1940–41*, with James Pope-Hennessy
 (London, 1941)
Time Exposure, with Peter Quennell (London, 1941);
 revised edition (New York, 1946)
British Photographers (London, 1944)
Photobiography (London, 1951); also published in America
 (New York, 1951)
Persona Grata, with Kenneth Tynan (London, 1953)
The Glass of Fashion (London, 1954)
*The Face of the World: An International Scrapbook of People
 and Places* (London, 1957)
Images, preface by Dame Edith Sitwell and introduction by
 Christopher Isherwood (London, 1963); also published
 in America (New York, 1963)
Royal Portraits, introduction by Peter Quennell (London, 1963);
 also published in America (New York, 1963)
The Best of Beaton, notes on the photographs by Cecil Beaton
 and introduction by Truman Capote (London, 1968)
*The Magic Image: The Genius of Photography from 1839
 to the Present Day*, with Gail Buckland (London, 1975)
*Photography in the Theatre: On and Off the Stage:
 McBean and Beaton* (York, 1975)

Other Publications

Happy and Glorious: Six Reigns of Royal Photography,
 Colin Ford (ed.) with contributions by Cecil Beaton et al.,
 (London, 1977)
Beaton, James Danziger (ed.) (London, 1980)
War Photographs, 1939–45, foreword by Peter Quennell and
 introduction by Gail Buckland (London, 1981)
Beaton in Vogue, selected and introduced by Josephine Ross
 (London, 1986)
Cecil Beaton, David Alan Mellor (ed.) (London, 1986)
Crown & Camera: The Royal Family and Photography 1842–1910,
 Frances Dimond and Roger Taylor (London, 1987)
Cecil Beaton: Royal Portraits, Sir Roy Strong (London, 1988)
Cecil Beaton, compiled by Philippe Garner and David Alan
 Mellor (London, 1994)
Cecil Beaton: Stage and Film Designs, Charles Spencer (ed.)
 (London, 1994)
Beaton Portraits, Terence Pepper, foreword by Sir Roy Strong
 and an essay by Peter Conrad (London, 2004)
The Royal Portrait: Image and Impact, Jennifer Scott
 (London, 2010)

Exhibition Catalogues

Cecil Beaton, Cooling Galleries (London, 1927)
Beaton Portraits 1928–68, National Portrait Gallery
 (London, 1968)
Fashion: An Anthology by Cecil Beaton, Victoria and Albert
 Museum (London, 1971)
The Photographs of Sir Cecil Beaton, Impressions Gallery of
 Photography (York, 1973)
The Royal Photographs of Sir Cecil Beaton,
 Victoria and Albert Museum (London, 1987)

Miscellaneous

Library of St John's College, Cambridge: 145 volumes of Cecil
 Beaton's diaries and personal correspondence
The Masque Library, no.2 (1947): Designs for the theatre by Rex
 Whistler [part I]; an appreciation by Cecil Beaton with
 foreword by Laurence Whistler (London, 1950)
V&A National Art Library Information File: Beaton, Cecil
V&A Archive of Art & Design: 47 volumes of Cecil Beaton's
 cuttings books

Acknowledgements

Sir Cecil Beaton's devoted secretary, Eileen Hose MBE, bequeathed the archive of Beaton's royal portraits to the Victoria and Albert Museum in the 1980s. It remains one of the largest collections of work by a single photographer held by the V&A. Images from the Beaton archive are licensed through V&A Images, generating income to purchase photographs for the permanent collection. Thus Beaton's legacy is both his magnificent creative output and ongoing input into the Museum's fund for new acquisitions. I am most grateful to Her Majesty Queen Elizabeth II for granting permission to reproduce, for the first time, a number of previously unpublished portraits from the Beaton archive.

Beaton's extensive diaries as well as previous publications on his royal portraits, particularly *Cecil Beaton: The Royal Portraits* (1988) by Sir Roy Strong, were a starting point for my research. I am particularly grateful to Sir Roy for his wealth of knowledge and advice. His Foreword to this publication adds a very special personal perspective. The Lady Rayne and Geoffrey Sawyer generously provided fascinating insights into sitting for, and working with, Beaton respectively. As one of the world's most sought-after portrait and fashion photographers, Mario Testino has photographed royalty on numerous occasions, and his Afterword highlights Beaton's continuing influence on twenty-first century photography.

My sincere thanks go to Hugo Vickers, Literary Executor to Sir Cecil Beaton, an authority on the photographer's life and editor of his extraordinary diaries, and to Terence Pepper OBE, likewise a Beaton connoisseur and Curator of the acclaimed 2004 exhibition *Cecil Beaton Portraits* at the National Portrait Gallery, London. Kathryn McKee, Sub-Librarian at St John's College, Cambridge, assisted me in researching the large collection of Beaton's diaries and letters in her care.

I am grateful to my V&A colleagues who assisted with this publication and the related exhibition, in particular Head of Research Christopher Breward, Senior Curators Liz Miller and Martin Barnes, Linda Lloyd-Jones and Tessa Hore in Exhibitions, the staff of the Research Department, Paper Conservation Studio, Photographic Studio and V&A Images, and my curatorial colleagues in the Photographs Section. I would also like to thank Laura Potter, Clare Davis and Mark Eastment in V&A Publishing, copy-editor Linda Schofield, and Maggi Smith for her elegant design. Anisa Hawes spent many weeks rationalizing the collection of Beaton negatives at the V&A and diligently expanding the digital catalogue records; her assistance has been invaluable. Intern Virginia Garramone assisted with bibliographic references.

Particular thanks are due to the staff of the Royal Collection and Buckingham Palace: Sophie Gordon and Lisa Heighway, Curators of the Royal Photographs Collection, who kindly shared their expertise on the Beaton works housed at Windsor; Jonathan Marsden, Director of the Royal Collection; Zaki Cooper, Assistant Press Secretary to the Queen, and Edward Young, Deputy Private Secretary to the Queen.

Picture Credits

Images and copyright clearance have been kindly supplied as listed below (in alphabetical order by institution or surname). All other illustrations, unless otherwise stated, are © V&A Images.

© David Bailey, p.53.
By permission of the Literary Executor of the late Sir Cecil Beaton and Rupert Crew Limited, pp.58–9.
© bpk/Erich Salomon, p.17.
© Bridgeman Art Library, pp.24 (*right*), 51 (*top*), 52 (*left*), 51.
Courtesy of the British Postal Museum & Archive, p.56 (*top right*).
© Camera Press, London, p.56 (*left*).
© Getty Images, pp.18 (*top*), 36, 49.
© William Hustler and Georgina Hustler/National Portrait Gallery, p.15.
© London Metropolitan Archives, p.44.
Courtesy of the Mrs W.M. Matthews Trust, pp.43, 48.
© The Metropolitan Museum of Art/Art Resource/Scala, Florence, p.24 (*centre*).
© National Portrait Gallery, pp.28 (*right*), 40–1, 54–5.
© Estate of Bertram Park/National Portrait Gallery, p.23 (*left*).
© The Irving Penn Foundation, p.57.
The Royal Collection © 2011 Her Majesty Queen Elizabeth II, pp.23 (*right*), 24 (*left*), 51 (*below*), 45, 46 (*left*), 47 (*left*).
© Lady Penn LVO/By permission of the Master and Fellows of St John's College, Cambridge, p.28 (*left*).
Estate of Paul Tanqueray/National Portrait Gallery, London, p.8.
© Mario Testino/Art Partner, pp.58, 60–1.

Index

Figures in *italics* refer to illustrations.

Albert, Prince 23
Alexandra, Princess 14, 40, pl. 26
Alice, Princess 23, 31–32, *31*
Andrew, Prince 48, 50, 51, pls 44–49
Anne, Princess Royal 42–44, 48, 49,
 pls 22–23, pl. 25, pls 39–40, pls 44–45
Annigoni, Pietro, *Queen Elizabeth II* 55, *56*
Armstrong-Jones, Antony 7

Bailey, David 52
 Cecil Beaton and Rudolf Nureyev 53
Beaton, Barbara ('Baba') *12*, 13, 42
Beaton, Cecil *8*, *15*, *16*
 contact sheets *34–35*, 42, pls 6–7, pl. 14,
 pl. 20, pl. 54
 cuttings books 30
 diary *38–39*
 drawings *40*, *41*
 at work *17*
Beaton, Nancy *12*, 13
Brunell, Theodore, *Princess Victoria
 and Princess Alice* 31, *31*
Buckingham Palace 26, 27, 28, 31, 33,
 34–35, *42*, 42, 52, 45, 48

Cambridge, St John's College Library 9
Channel Island stamps 52, 56, *56*
Charles II, King 44
Charles, Prince of Wales 42–44, 48–49,
 48, *49*, *61*, pl. 22, pl. 24, pls 35–36,
 pls 40–45
Charlotte, Queen 24
Charteris, Martin 45–46, 52
Clarence House 49

Daily Sketch 13, 27, 33
Downey, W. & D. 20, 25
 portrait of King Edward VII *18*
 Princess Alexandra carries her
 daughter Louise on her back 49, *49*

Edward, Prince 48, 50, *50*, 51, pls 46–47,
 pl. 49
Edward VII, King *18*, 20, 44
Elisabeth of Bavaria, Empress of Austria
 24, *24*
Elizabeth II, Queen
 Annigoni portrait *56*
 Coronation 36–42, *37*, 46, 47, pls 19–21
 March 1960 pls 44–45
 May 1964 pls 49–50

November 1955 pls 30–31, pl. 33
 as Princess Elizabeth 9, 27, 28, *29*, 32,
 32, 33, pls 1–5, pls 8–15, pl. 35,
 pls 37–39, pls 41–43
 on Princess Margaret's wedding day
 pl. 34
 September 1968 *11*, pls 50–58
Elizabeth, Queen, the Queen Mother
 9, 20–31, *21–23*, *25–27*, *29*, 36, 40, 42–44,
 51–52, pl. 1, pl. 8, pl. 22, pls 24–25,
 pl. 27
Elliott, Grace Dalrymple 24, *24*

Fragonard, Jean-Honoré 26
 Le petit parc 32, *32*, 33

Gainsborough, Thomas 24
 The Artist's Daughters 31, *31*
 Grace Dalrymple Elliott 24
 Queen Charlotte 24, pl. 8
George VI, King 20, 22, 24, 36, pl. 8
Gloucester, Duchess of 20
Goodall, Edward (after David Roberts),
 *View of the Debarkation on Lord
 Mayor's Day* 44
Gunn, Sir Herbert James, *Queen
 Elizabeth II in Coronation Robes*
 45, 47

Harper's Bazaar 14, 52
Harry, Prince *60*, *61*
Hartnell, Norman 33, 37–40
 design for Coronation dress *36*
Hayter, Sir George, *Queen Victoria* 45, *45*
Hose, Eileen 9, 51

Illustrated Weekly of India 26
'In the Manner of Edwardians' *19*

Kent, Duchess of 20, 42, pl. 26
Kent, Duke of 20, 42, pl. 26

Life magazine *32*

Margaret, Princess 27, 28, *29*, 40, 42,
 pls 1–2, pl. 4, pl. 8, pls 13–14, pl. 27
 wedding of pl. 34
Matthews, Patrick 42
 Cecil Beaton and assistants *43*
 Cecil Beaton photographing Sister
 Rowe and Prince Charles *48*
Meyer, Baron Adolf de 14, 17
 unpublished fashion study *13*

Michael of Kent, Prince pl. 26
Moffat, Curtis 17
 portrait of Cecil Beaton *16*

National Portrait Gallery, *Beaton
 Portraits 1928–68* (1968) 52–56, *54*, 55
Nureyev, Rudolf 52, 53

Park, Bertram, Duchess of York *23*
Penn, Arthur 28, *28*
Penn, Irving, Cecil Beaton *57*
Philip, Prince, Duke of Edinburgh 45, 46,
 49, pl. 18, pls 44–45

Rayne, The Lady 46–47
Rose, Francis 18, *18*
Rowe, Sister Helen *48*, 49, 50
Royal Collection 28
Ryall, H. T. (after Hayter), *Queen Victoria*
 45, *45*

Salomon, Erich, Cecil Beaton at work *17*
Sawyer, Geoffrey 51, 55
Silvy, Camille 24
 Princess Alice *23*
Strong, Sir Roy 31, 52

Tanqueray, Paul 14
 Cecil Beaton *8*
Testino, Mario 59
 Prince Charles *58*, *61*
 Prince Harry *60*, *61*
 Prince William *60*, *61*

Vanity Fair 13, 14, 17
Victoria and Albert Museum, *Fashion:
 An Anthology by Cecil Beaton* (1971) 9
Victoria, Princess Royal 31–32, *31*
Victoria, Queen 20, 23, 44
Vogue 9, 14, 17, 42, 51, 52

Westminster Abbey 36, 42, 45
Wilding, Dorothy 56
 Cecil Beaton in costume 14, *15*
William, Prince *60*, *61*
Windsor Castle 31, 33, pls 6–7, pl. 98
Winterhalter, Franz Xaver 24, pl. 3
 *Elisabeth of Bavaria, Empress of
 Austria* 24
 The Royal Family 51
Wright, John Michael, Charles II 45, *46*